PAST & PRESENT

PULASKI COUNTY

Gov. William Fulton Home, 1860. William Fulton was the last territorial governor of Arkansas before statehood in 1836. When he moved to Little Rock in the 1820s, he bought property in the city and named it Rosewood. Fittingly, Rosewood is the current site of the Arkansas governor's mansion. (Courtesy of the Arkansas State Archives.)

PAST & PRESENT

PULASKI COUNTY

Brian David Irby

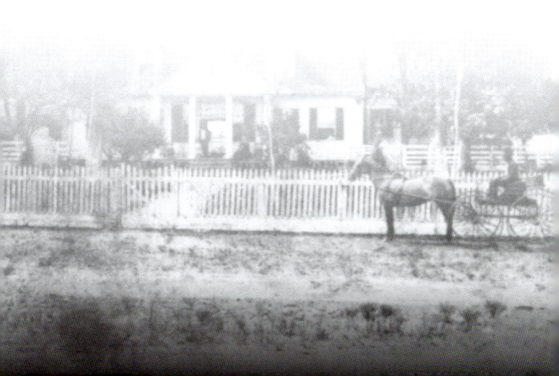

For Jennifer.

Copyright © 2024 by Brian David Irby
ISBN 978-1-4671-6094-0

Library of Congress Control Number: 2023947750

Published by Arcadia Publishing
Charleston, South Carolina

Printed in the United States of America

For all general information, please contact Arcadia Publishing:
Telephone 843-853-2070
Fax 843-853-0044
E-mail sales@arcadiapublishing.com

Visit us on the Internet at www.arcadiapublishing.com

ON THE FRONT COVER: Little Rock's Main Street was a hub for commerce in the 1940s, and continues to be so today. (Then, courtesy of the Arkansas State Archives; now, author photograph.)

ON THE BACK COVER: Finished in 1914, Arkansas's capitol building is one of the most recognizable landmarks in Pulaski County. (Courtesy of the Arkansas State Archives.)

Contents

Acknowledgments		vii
Introduction		ix
1.	Pulaski County is Born	11
2.	Pulaski County Enters the Gilded Age	27
3.	Pulaski County at the Turn of the Century	45
4.	Pulaski County Enters the Progressive Era	59
5.	Pulaski County in the Modern Age	77

Acknowledgments

I would like to thank my wife, Jennifer Irby, for her moral support through this project and for helping me with the modern photography; David Ware, for handing me this project; and the entire staff of the Arkansas State Archives, especially Heather Reinold, for their enthusiasm and candor. Also, thanks go to Ray Screws at the Camp Robinson Military Museum for taking me around Camp Robinson on the hottest day of the year, and Abbie Deville for helping me take some of the modern photographs in this book. Additional thanks go to Danielle Asfordeh for her help.

All historical photographs are courtesy of the Arkansas State Archives. All modern photographs are courtesy of the author, except where noted.

Introduction

Telling the story of Pulaski County from its infancy to the present is a challenging task. The county has existed for two centuries, and over the years, its communities have developed from small rural hamlets to bustling cities. It is a story as complex as its people. I have taken on a novel premise: tell the story of Pulaski County through pictures from the photographic collection of the Arkansas State Archives. I feel I must make a quick summary of what the reader will experience in the following pages.

When European settlers began entering what would become Pulaski County, the Quapaw, a tribe of indigenous people who had come to the area from the Ohio River Valley, had been living in the area since the 16th century. Hernando De Soto came through in 1541. Benard de la Harpe ascended the Arkansas River in 1682 past the large outcrop of rock on its north side. Other French explorers traveled through the area and called the smaller rock outcropping on the south of the river La Petit Roche, or "the Little Rock."

In 1803, Napoleon sold the land to the US government in the Louisiana Purchase. Arkansas was a part of the Orleans Territory and then the Missouri Territory, and in 1819, it became its own territory. The new territorial legislature's first significant act was to divide Arkansas Territory into counties. In 1820, the legislature created Pulaski County as one of the first counties in the territory.

Thomas Nuttall, an explorer, arrived in Pulaski County in 1818. Nuttall was a naturalist who noted a few families living along the river, close by the "little rock." Settlement in the county increased greatly when the territorial legislature voted to move the capital from Arkansas Post to Little Rock. By early 1820, several families had settled in Pulaski County, with more to come.

With Little Rock as the seat, merchants, farmers, lawyers, and politicians came to the new county and established residences. A few settlements, such as Crystal Hill and Pyeatt, sprung up outside of Little Rock but the seat of government attracted the majority of immigrants. Travel was difficult; the few roads were rudimentary at best. The most reliable form of transportation remained the Arkansas River, and Little Rock's proximity to it was a boon to the city. The rest of the county remained rural, with lesser settlements dotting the landscape.

The Quapaw sought to remain in the Arkansas valley but faced strong pressure to quit the area. Euro-American settlers complained that the Quapaw had held onto the best farmland, and the territorial government sided with them. After a series of lopsided treaties, the Quapaw were driven out of the county and into northern Louisiana where they would almost starve, while white settlers continued to flood into the county.

In 1836, Arkansas became the 25th state of the Union. The distribution of slaves in Arkansas followed the distribution of agriculture, mostly cotton. There was some cotton cultivation in southern Pulaski County, but not as much farther north in the county. With the coming of the Civil War, there were pockets of resistance to secession at the outset. However, Pulaski County's

white residents for the most part tucked their heads to their chests and hoped the storm would soon pass. In 1861, Arkansas seceded from the Union, joining the Confederacy at the beginning of the Civil War. For Pulaski County, the war meant that many provisions became scarce. When Sterling Price's Union army captured Little Rock in 1863, it essentially ended the war in Pulaski County.

Over the next several years, the Reconstruction government made progress in developing education and establishing voting rights for freed slaves despite resistance from the conservatives—old-line former Confederate loyalists, mostly Democrats—and from a faction of the state's Republican party. Reconstruction ended with a bang with the Brooks-Baxter War, an armed conflict between factions of the Republican Party, concluding with violence on the streets of Little Rock. By the end of 1874, Reconstruction was a dead letter in Arkansas and the conservative Democrats retook control of state government.

By the 1880s, Pulaski County had emerged as a Gilded Age county, and Little Rock was a rising Gilded Age city, with its amenities attracting and serving the population of the county beyond its limits. Merchants and lawyers built large mansions that attested to their wealth as railroad barons and commodity traders. To the north of the city, Argenta and Baring Cross were born, the beneficiaries of railroad commerce. Outside of the central part, the rest of Pulaski County remained rural. By the turn of the 20th century, however, new communities began as the population continued to grow. Immigrants from Europe settled in the county during this time and formed communities. German immigrants settled in Little Rock and prospered. Polish immigrants founded Marche, and Italian immigrants founded Little Italy.

The two world wars brought more residents as soldiers came to train at Camp Pike in northern Pulaski County and later at Camp Robinson. Jacksonville transformed from a small village to a town when the US military established an ordnance plant there. Jacksonville continued to grow as the US Air Force established a base at the north end of the town. With the automobile, residents were more mobile, and suburbs appeared as people spread out through the county.

In the 21st century, many of the trends that marked the previous two hundred years have continued. Little Rock has gotten larger, as has the rest of the county. This has brought numerous changes in the county's landscape, which can be viewed through the old photographs collected in this book. I have tried to present the county as it was, though the reader might find obvious holes in my coverage—I have been constrained by what our forebears wanted to photograph. What I have found, though, is that the collection at the Arkansas State Archives, where these photographs are preserved, presents a wide swath of Pulaski County's history.

CHAPTER 1

PULASKI COUNTY IS BORN

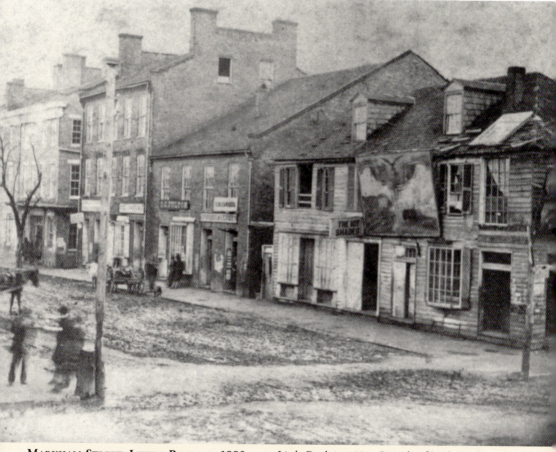

MARKHAM STREET, LITTLE ROCK, C. 1880. Pulaski County was created in 1819, becoming one of the first counties established when Arkansas Territory was formed. The county grew in political importance with the move of the territorial government from Arkansas Post to Little Rock in 1821. Outside of Little Rock, Pulaski County remained rural, with small farms dotting the landscape and few towns of more than a handful of people. Transportation outside of Little Rock remained rudimentary.

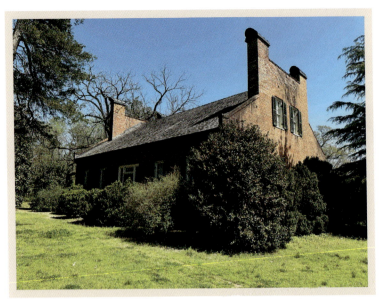

TEN MILE HOUSE. The main artery bringing settlers to Arkansas was the Southwest Trail, a road that ran from Missouri southwest to Texas. Settlers established their homes along the trail. One of the new settlers was Archibald McHenry, who came to central Arkansas around 1819. He built this home on the present Stagecoach Road between 1822 and 1835. One of the few homes standing from the 1820s, the house has changed little in the past two centuries.

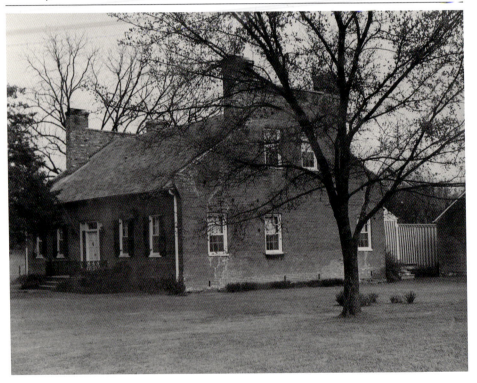

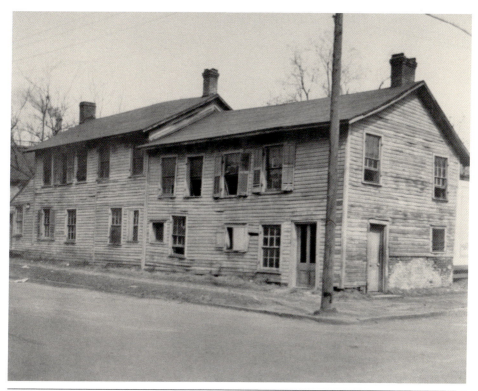

HINDERLITER GROG SHOP. Jesse Hinderliter, a St. Louis native, came to Little Rock in the 1820s. He purchased three lots from Chester Ashley and built this house. On the first floor, he opened a tavern, selling watered-down whiskey to travelers. Disagreements between drunk travelers often erupted into brawls. After Hinderliter's death in 1834, the building continued to be a boardinghouse and a restaurant. The building is now part of the Arkansas Historic Museum.

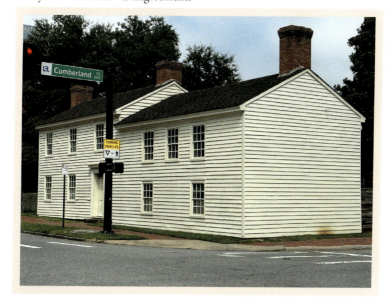

PULASKI COUNTY IS BORN

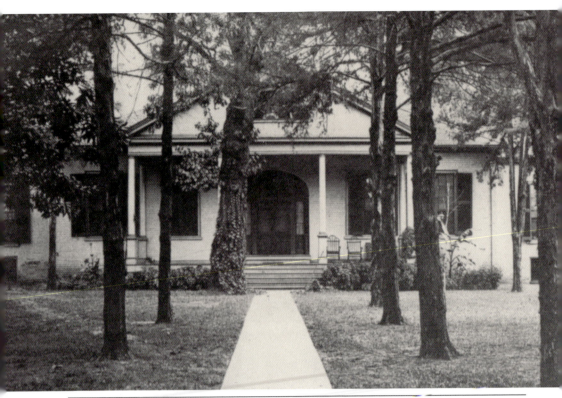

ROBERT CRITTENDEN HOUSE. In the 1820s, Arkansas's territorial capital moved from Arkansas Post to Little Rock. Most governors spent little time in the territory, leaving a political vacuum. An enterprising Kentuckian, Robert Crittenden, wielded power as territorial secretary in the governor's absence. He built this Greek Revival home on the corner of Scott and Seventh Streets. In the 1920s, it was demolished and replaced by the Albert Pike Hotel.

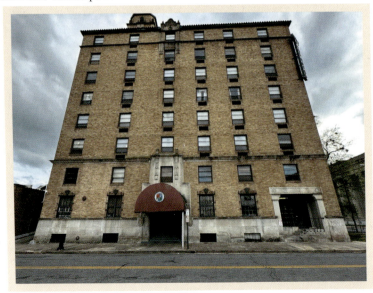

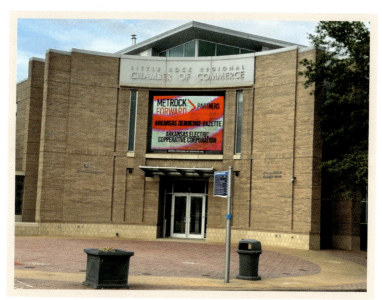

CHESTER ASHLEY HOUSE. Arkansas's new legislature decided in 1820 to move the territorial capital to a new location, eventually settling on Little Rock. Instantly, land speculators bought up large tracts of land. One of those who made large profits was Chester Ashley, who later became a US senator. His home on Markham Street was converted into a hotel after his death; the hotel was demolished in the 1910s.

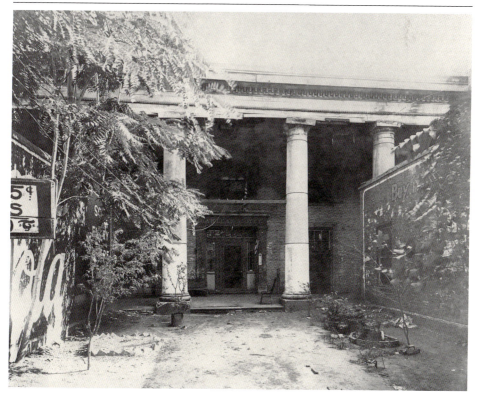

PULASKI COUNTY IS BORN

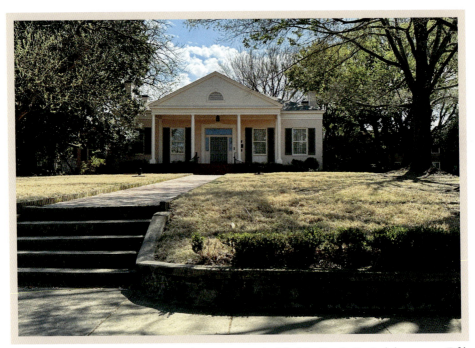

FREDERICK W. TRAPNALL HALL. A native of Kentucky, Frederick W. Trapnall came to Arkansas in 1836 and quickly established a law office in Little Rock. His reputation grew rapidly, and by 1842 he was prominent enough to build this Greek Revival house on Fifth Street (now Capitol Avenue). The building has served a number of functions over the years. Currently, the house serves as the governor's reception space.

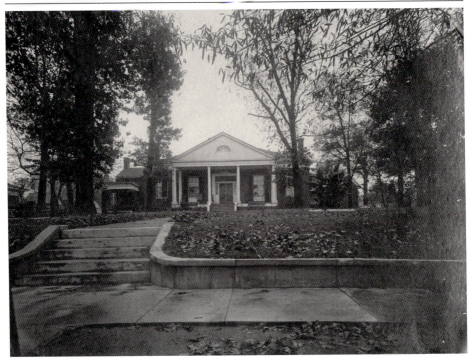

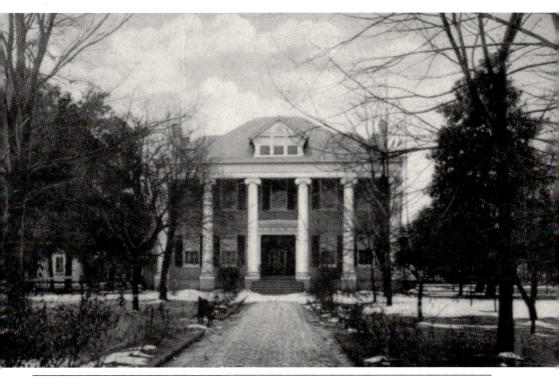

PIKE-FLETCHER-TERRY HOUSE. Albert Pike was a politician, soldier, poet, newspaper editor, and lawyer. He built this Greek Revival house in 1840. Over the years, changes have been made to the structure. It was later the residence of John G. Fletcher. Fletcher's daughter Adolphine was active in the suffrage movement. In 1964, she gave the house to the City of Little Rock for use by the Arkansas Arts Center. The house is now vacant.

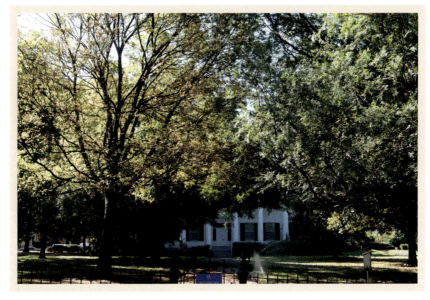

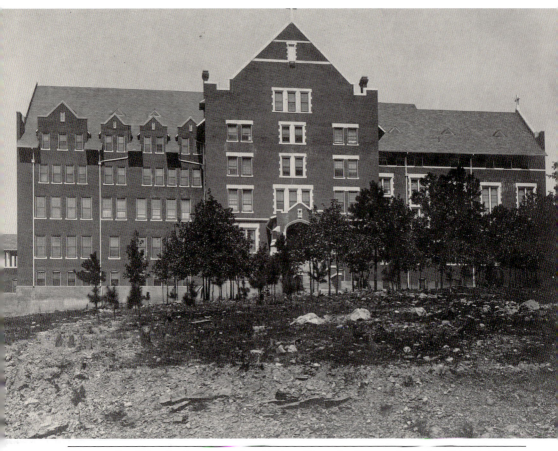

Mount St. Mary's Academy. In 1851, Bishop Andrew Byrne of the Little Rock Diocese invited the Sisters of Mercy to central Arkansas to support the growing Catholic community. The sisters founded Mount St. Mary's Academy to educate Catholic children. The school moved to the Pulaski Heights neighborhood in 1908 and built this building on top of a hill. By 1982, the building was increasingly expensive to maintain, and the sisters made the decision to demolish it.

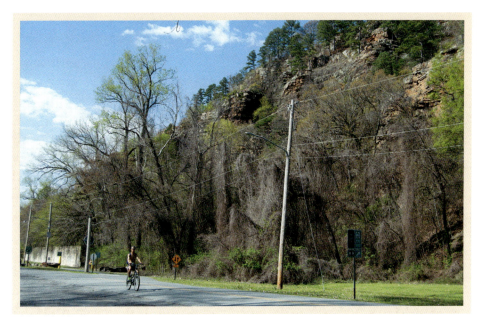

BIG ROCK QUARRY. The new city required a lot of building materials. Since transportation remained difficult, much of the materials had to be acquired locally. North of the river is a large geologic formation that became a stone quarry. The quarry produced enough stone to furnish materials for building the new city. The quarry remained in operation for over a century. Today, the quarry's ruins can be seen from a bicycle trail near Burns Park in North Little Rock.

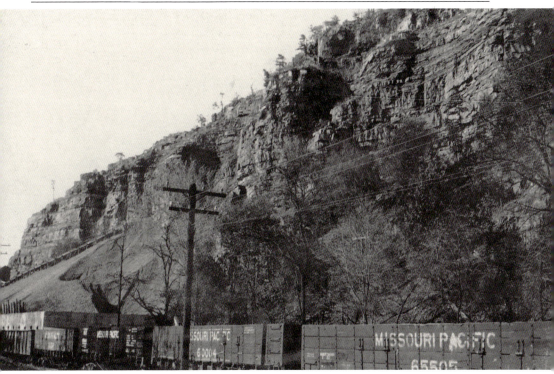

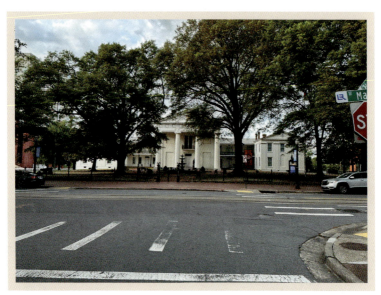

OLD STATE HOUSE. Arkansas Territory began to lobby for statehood in the 1830s. Up to that point, the territorial legislature had worked in rented rooms in wooden shacks that dotted the small village. The US Congress gave the territorial legislature federal land to sell to raise money to build a capitol building. The legislature contracted Gideon Shryock to design the new building. Construction began on the Greek Revival structure in 1833, and it opened in 1836.

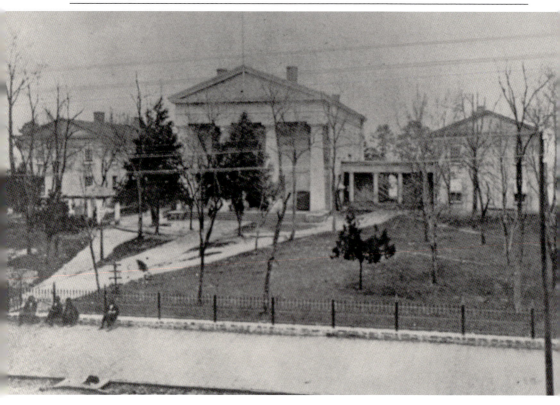

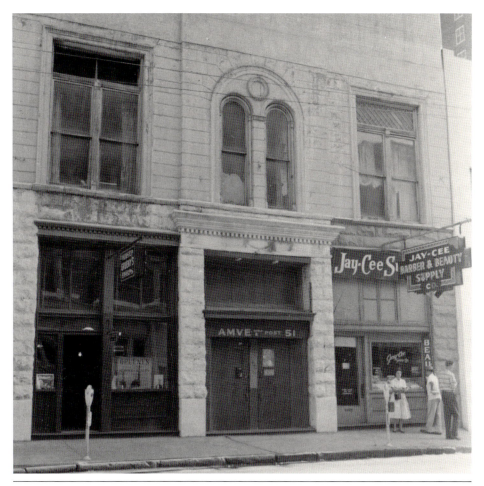

OLD LITTLE ROCK CITY HALL. In 1867, city officials built a city hall at 120–122 Markham Street. The building was used for a variety of purposes. Overuse led to it falling into disrepair. In 1888, William Armour Cantrell proposed a new city hall. The old city hall served as a commercial storefront until it was demolished. Today, the site is occupied by the Statehouse Convention Center.

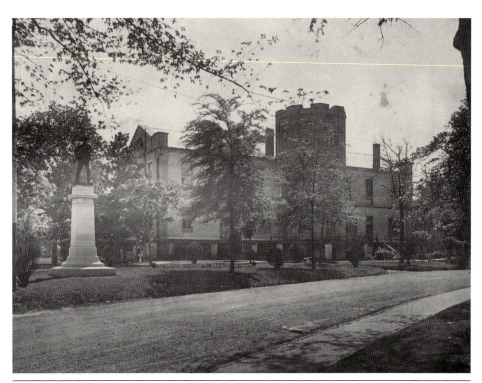

LITTLE ROCK ARSENAL. In 1836, the Little Rock Arsenal was established as a military installation. After Arkansas seceded from the Union, the federally-owned arsenal building became a flash point when a thousand secessionist militia soldiers surrounded the building and demanded its surrender. Bloodshed was avoided when the commander abandoned the building to the Confederates. After the war, it remained a military installation and was the birthplace of Gen. Douglas MacArthur.

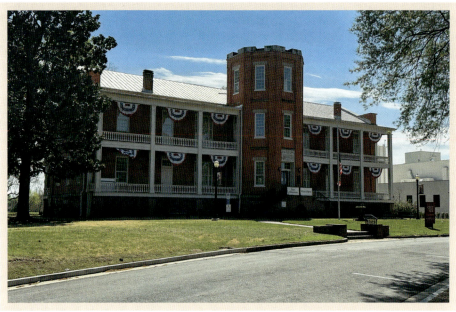

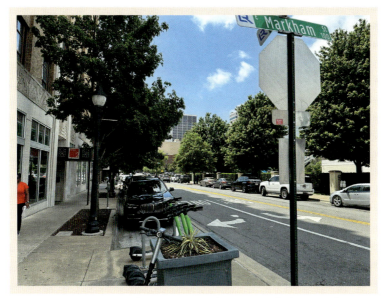

MAIN STREET, LITTLE ROCK, 1863. Union forces captured Little Rock in 1863. After experiencing resistance from Confederates in eastern Pulaski County, they found a population tired from warfare. After talking with some of the Confederate prisoners captured in the city, H.S. Drinkle, a Union sergeant, wrote, "I saw a hundred of them and they look hard—and don't think we can get another fight out of them."

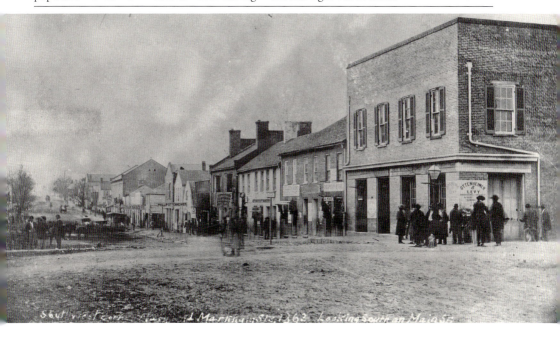

Pulaski County is Born

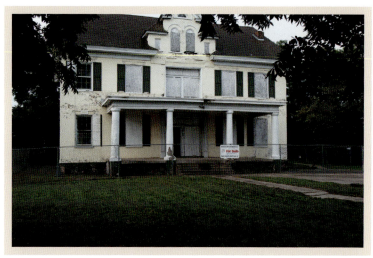

WILLIAM WOODRUFF HOUSE. William Woodruff came to Arkansas Territory in 1819 and founded Arkansas's first newspaper, the *Arkansas Gazette*. In 1820, he relocated to Little Rock and built this Greek Revival home on Eighth Street. When General Steele captured Little Rock, he banished Woodruff from the city and used the house as a field hospital. The house was significantly damaged by fire in 2005 and is vacant today. (Present, courtesy of Abbie Deville.)

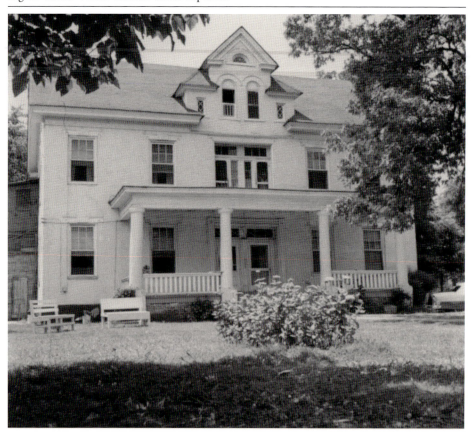

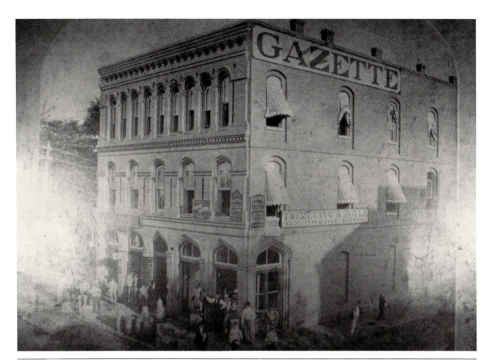

ARKANSAS GAZETTE BUILDING. The *Arkansas Gazette* had been the statewide newspaper of record for decades by the time this photograph was taken in the 1880s. During the war, the *Gazette* suspended operations and changed ownership several times in the two decades following the conflict. Despite competition, it flourished in the early 20th century. It moved from this building to a new home in 1908; its former building was demolished.

Pulaski County is Born

25

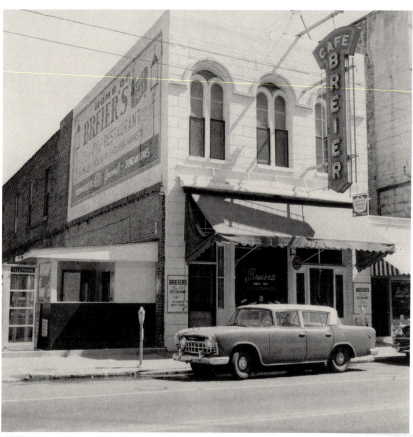

LITTLE ROCK REPUBLICAN OFFICE. After the Civil War, Arkansas entered the period of Reconstruction. While the *Arkansas Gazette* opposed many of the Reconstruction policies, Republicans founded the *Morning Republican* to support Republican governor Powell Clayton's policies. The newspaper was published from 1867 to 1872. After the paper closed, the office at 134 East Markham Street housed Breier's Restaurant. After Breier's closed in the 1970s, the building was torn down.

CHAPTER

Pulaski County Enters the Gilded Age

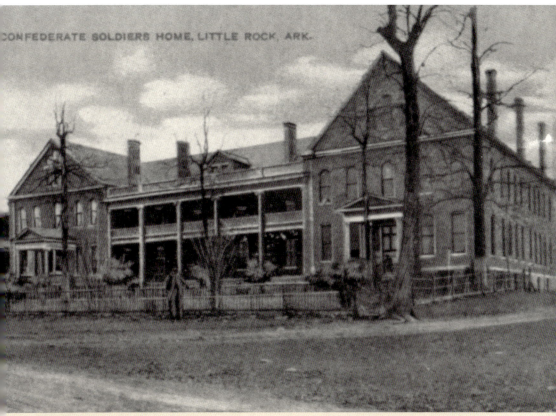

Confederate Soldiers' Home, Sweet Home. During the Gilded Age, the old planter aristocracy began to give way as new professions began to emerge. Bankers and merchants began to take on the mantle of community leadership. Land ownership, the gauge of prosperity in the prewar days, was replaced by finance and industry. In 1892, the state built the Confederate Soldiers' Home in Sweet Home to care for indigent soldiers.

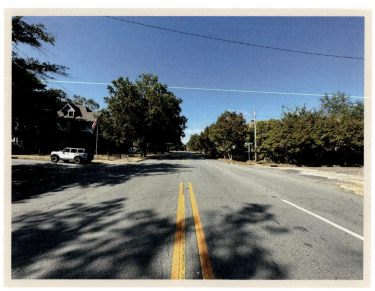

BROADWAY LOOKING NORTH. Little Rock began to spread south as its prosperous citizens built large homes. Broadway became an important artery southward as new neighborhoods appeared adjacent to the busy thoroughfare. What is now the Governor's Mansion District was one such neighborhood. Today, this road is still vital to the city, and many of those houses are still in high demand.

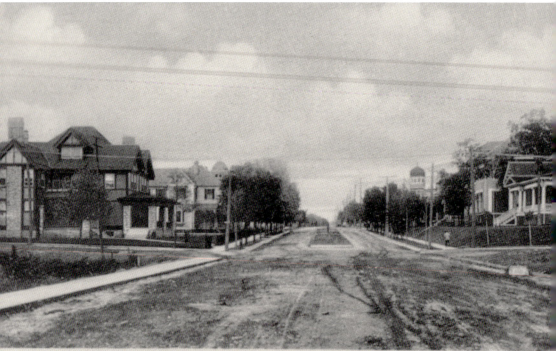

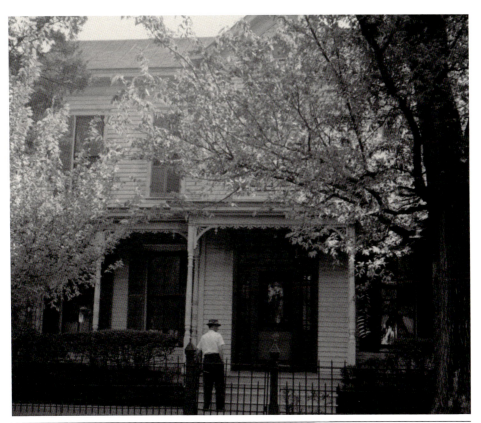

RECIHARDT-HOETZELL HOUSE. Edward Reichardt was born in Austria and immigrated to Arkansas in the 1850s. He entered a partnership in Little Rock with his brothers in law to establish a cotton trading company. He built this house on Welch Street, part of the Hangar Hill neighborhood. He added to the one-story house as his business and family grew. He died in 1883. His daughter Emma was an advocate of women's suffrage and held various civic and political offices.

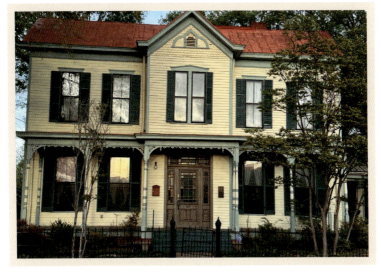

Pulaski County Enters the Gilded Age

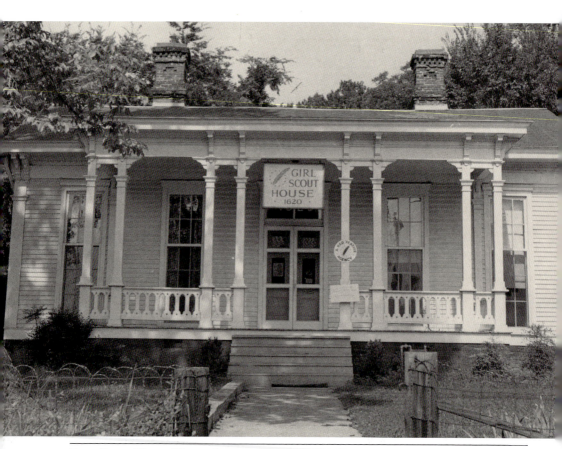

FIRST PETER HOTZE HOUSE. Peter Hotze was another Austrian immigrant who moved to Arkansas in the 1850s. When the Civil War erupted, Hotze joined the Confederate army and was captured at the Battle of Franklin. After the war, Hotze built this Italianate-style house. It served as a private school in the 1930s. It was renovated in 2002 and is now the home of an architectural firm.

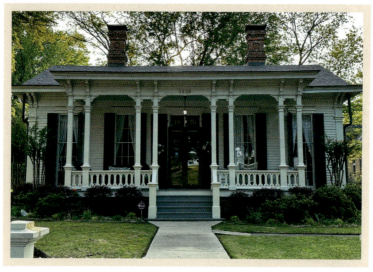

THE CAPITAL THEATER. As the city boomed, so did the arts. In 1885, the Capital Theater opened. The building was designed by W.O. Thomas and had a seating capacity of 1,500 people. In the first year of operation, it hosted traveling acting troupes from across the country, and political stump speeches. The theater was the premier venue for entertainment in the city. It moved to a new location and thrived, and the old building was demolished.

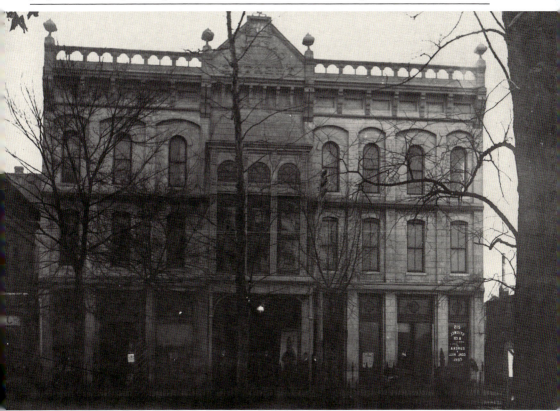

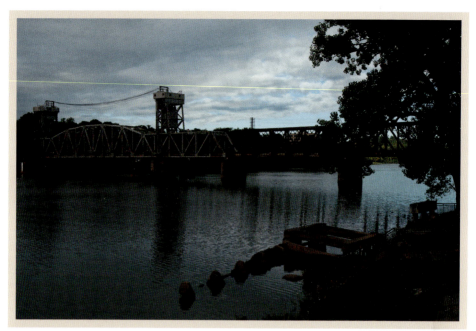

Baring Cross Bridge. In 1872, the Cairo & Fulton Railroad Company began work on the first railroad bridge between the small community on the north side of the river and Little Rock. The bridge was named after financier Baring and Company. In 1877, the company added a toll highway on top of the bridge. The highway has since been removed and the bridge is now used solely for rail traffic. (Present, courtesy of Abbie Deville.)

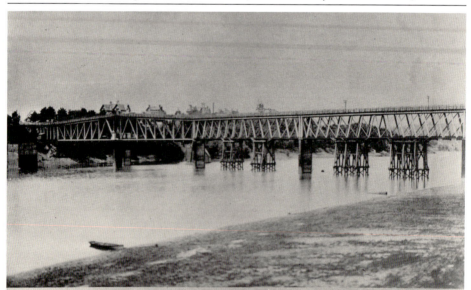

Baring Cross Bridge, Arkansas River, Little Rock, Arkansas showing highway bridge on top. Photograph in 1890 when decayed wooden chords were replaced with steel. See page 44.

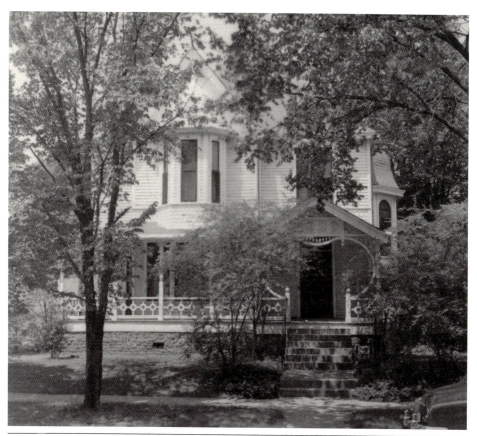

FREDERICK HANGER HOUSE. In 1889, Frederick Hanger moved into a newly remodeled home on Scott Street in Little Rock. He advanced in the Arkansas Granite Company to become secretary and treasurer. He also branched out into cotton cultivation. Hanger was killed in a mining accident in 1900. His wife became involved in several civic activities and was president of the Arkansas Federation of Women's Clubs. The house remains a residential property.

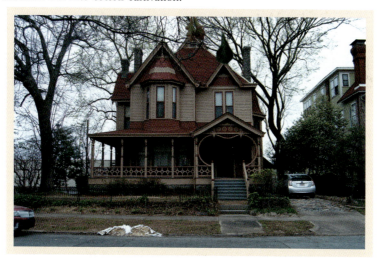

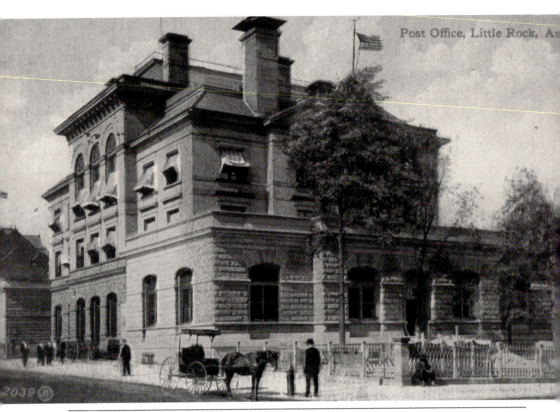

LITTLE ROCK POST OFFICE. Railroads improved mail delivery, speeding up the process greatly. Cities such as Little Rock constructed new post office buildings, such as this one on Second Street, finished in 1881. After the post office moved from this location, the building has been home to the University of Arkansas Little Rock's law school and currently is the location of the US Bankruptcy Court and US Marshals Service.

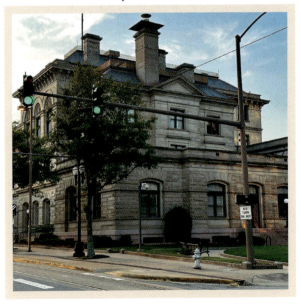

PULASKI COUNTY LAND OFFICE. The Pulaski County land office was conveniently located next to the train depot. It was expected that it would be one of the first stops for new settlers in the city. Land sold briskly in the county. The Little Rock land office reported in 1877 that it sold 81,000 acres. Land developers began platting out new neighborhoods in the city. Advertisements for large tracts of land filled the newspapers.

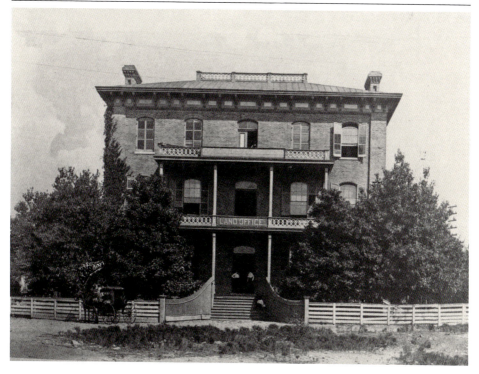

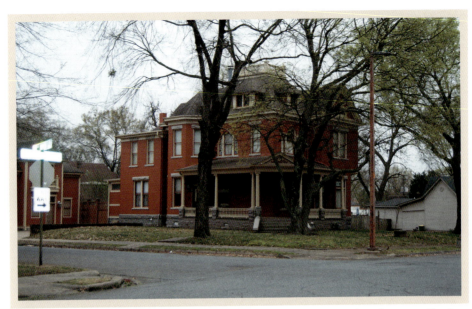

Cosper Altenberg House. Cosper Altenberg was born in Indiana. At the outbreak of the Civil War, he joined the 30th Regiment of the Indiana Infantry. He served until he was wounded in Alabama in 1862. After the war, Altenberg moved to Little Rock to serve as a pension agent for Union veterans. He built this Queen Anne–style home on Cumberland in 1889.

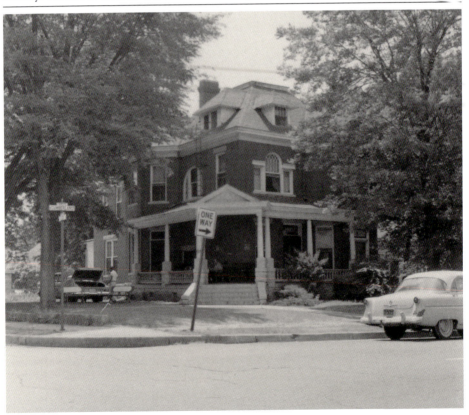

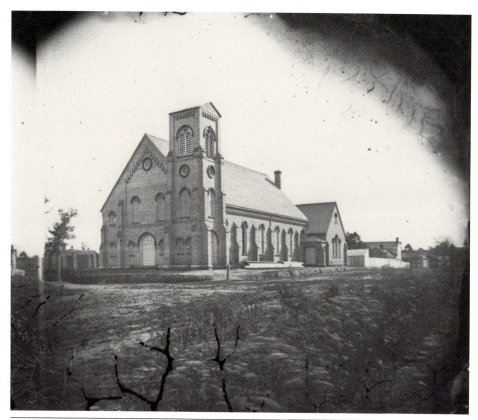

FIRST PRESBYTERIAN CHURCH. Fires were a constant threat in Little Rock. In 1866, the Little Rock City Council decreed that all large buildings were required to be built with stone or brick. In that same year, a fire erupted in the city, destroying the Presbyterian church. The congregation relocated to Fifth and Scott Streets and built this church, which opened in 1869. The church moved to Eighth and Scott Streets in 1914.

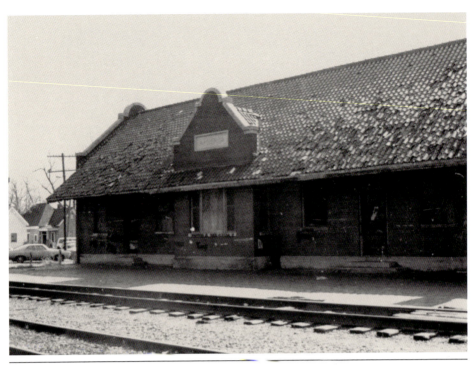

THE ARGENTA DEPOT. Railroads were important to the development of Pulaski County. During the Civil War, Confederate engineers began building a train depot on the north side of the Arkansas River to supply Little Rock and Confederate soldiers. The Rock Island Argenta depot was completed in 1913. Although vacant today, it remains a testament to the thriving Argenta community and the railroads that gave it birth. (Present, courtesy of Abbie Deville.)

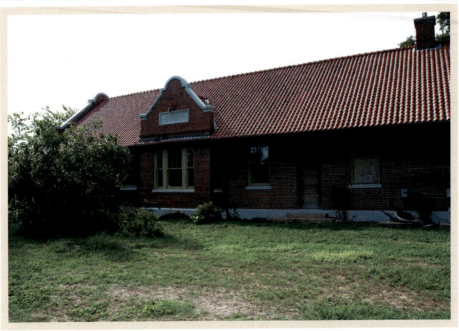

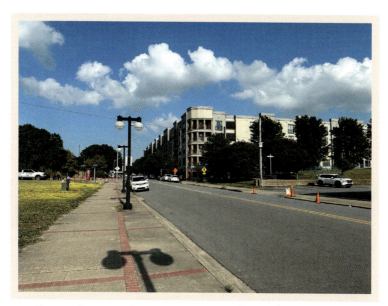

WASHINGTON STREET, ARGENTA. Argenta was a typical railroad town. Saloons lined its main roads, and often, arguments between drunken card players could be heard in the streets. The *Arkansas Gazette* complained in 1880 that there was no law in the town. In 1890, Little Rock annexed the town, but it did not last long. In 1904, Argenta regained its independence and was subsequently annexed to the City of North Little Rock.

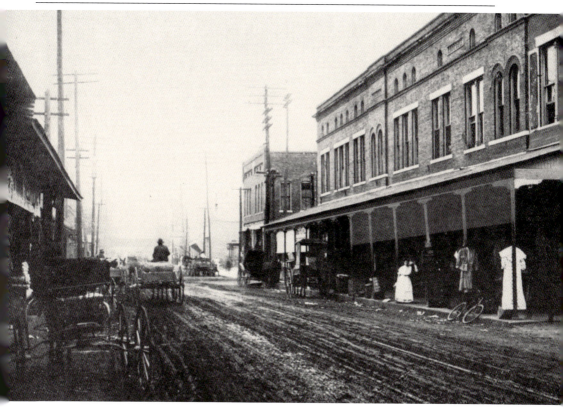

Pulaski County Enters the Gilded Age

LITTLE ROCK, MAIN FROM SECOND. The period after the Civil War saw a dramatic change in Little Rock. The capital city's skyline slowly transformed as fire-resisting brick buildings gradually replaced earlier wooden structures. Brickyards owned by businessmen such as John Robbins offered bricks at the low price of $8 per 1,000 bricks. This made building these structures inexpensive.

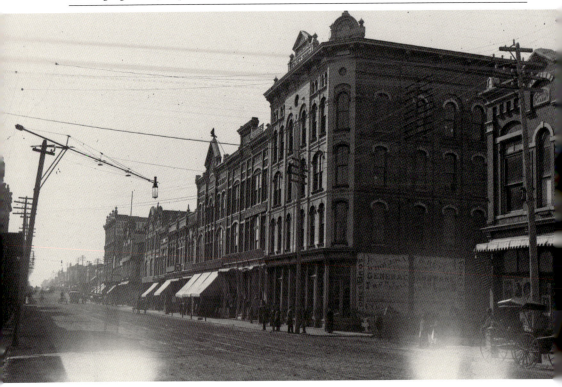

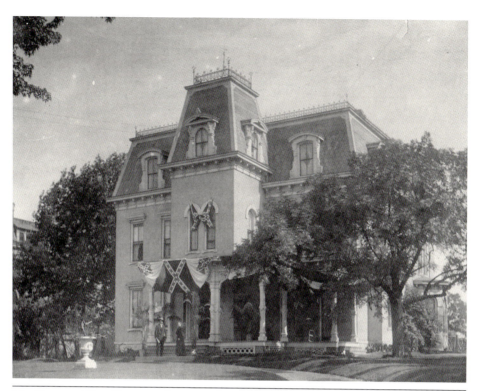

MacDonald-Wait-Newton House. After the Civil War, many Republican politicians came to Arkansas. They were among those derisively called "Carpetbaggers" by Arkansas's Democrats, Northern businessmen, and politicians who served in Arkansas's government. Alexander MacDonald, a Pennsylvania native, became a US senator from Arkansas, serving only one term until losing reelection in 1871. In the meantime, he built this Second Empire home on "Carpetbaggers' Row" on Lincoln Avenue, later renamed Cantrell Avenue.

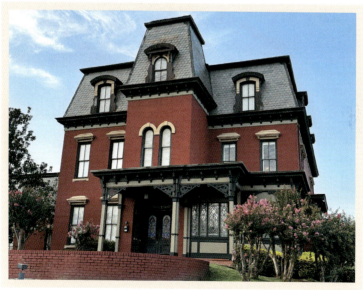

Pulaski County Enters the Gilded Age

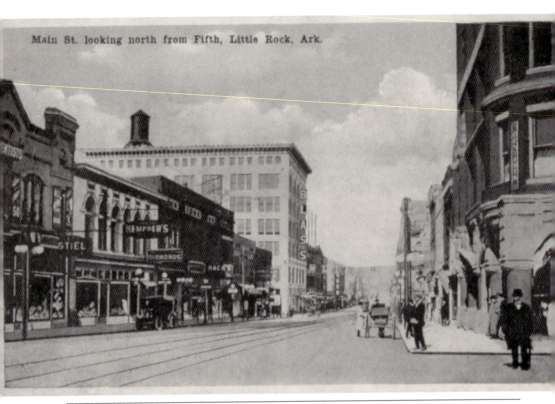

LITTLE ROCK, MAIN NORTH FROM FIFTH. Gus Blass came to Little Rock from Germany in the 1860s. In 1867, he began selling goods out of a box on a street corner on Main Street. With help from his brothers, he opened his first store in 1871 in a small 12-by-18-foot structure, and later moved into this building on Main Street. Today, the seven-story tower is home to the Office of Child Support Enforcement.

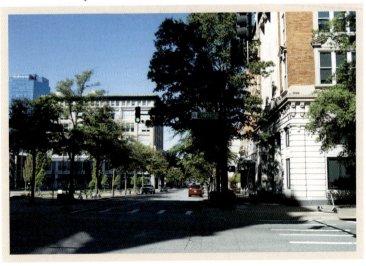

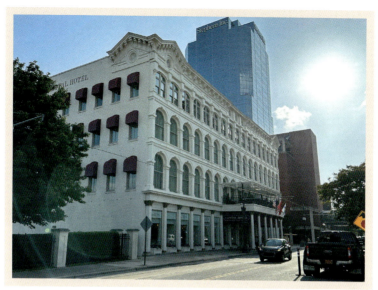

THE CAPITOL HOTEL. The Capitol Hotel began life in 1872 as a suite of storefronts selling goods to Little Rock's growing population. By 1876, the block's general manager decided to convert it to a grand hotel to meet the needs of visitors to the city. Renovations completed, the hotel opened in January 1877. Dignitaries staying in the hotel included Pres. Ulysses S. Grant in 1880. In the late 1970s, the building was renovated and reopened in 1983.

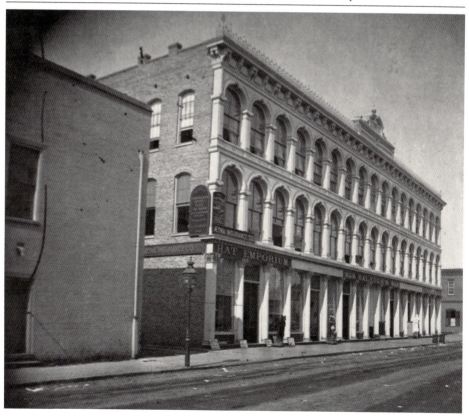

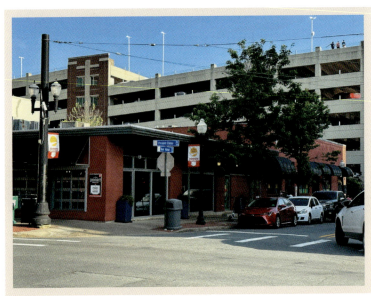

WEHRFRITZ MACHINERY COMPANY. In 1876, Emil Cornelius Wehrfritz, a native of Germany, moved to Little Rock. He worked in machine shops around the city until he was able to raise enough money to start his own business. He opened Union Machine Works in 1885, later changing the name to Wehrfritze Machinery Company. His business thrived on the corner of Second and Main Streets. Wehrfritz grew prosperous enough to serve on the city council and ran unsuccessfully for mayor.

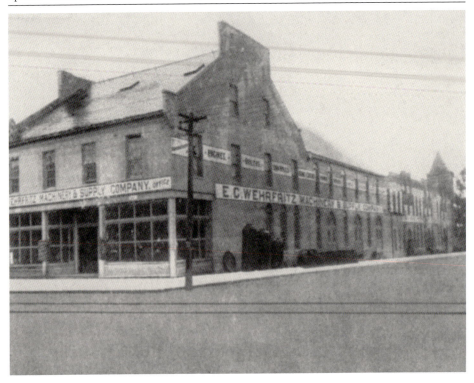

CHAPTER 3

Pulaski County at the Turn of the Century

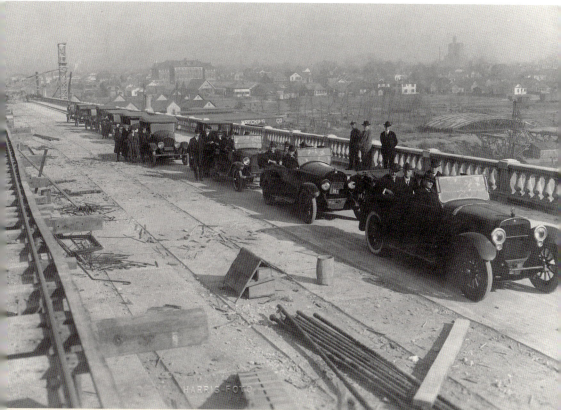

First Traffic Crossing Broadway Bridge. Automobile traffic in central Arkansas increased dramatically in the first decades of the 20th century. As a result, infrastructure became strained. In 1918, Little Rock city officials decided to build a new bridge on Broadway to relieve congestion over the river. The bridge was completed in 1923 and replaced in 2017. Many changes were happening as the county entered the new century.

GERMAN SAVINGS BANK. In 1841, the Arkansas State Bank failed, bringing the economy of the state to its knees. Because of the financial disaster, it took several years for banks to reappear in the state. One of the first was the German Savings Bank, organized in 1875. Fearing anti-German sentiment during World War I, the bank changed its name to the American National Bank. It occupied the corner of Second and Main Streets until its demolition in the 20th century.

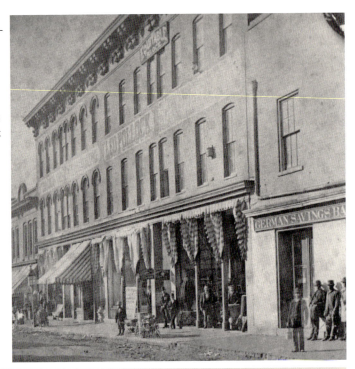

PULASKI COUNTY COURTHOUSE. Despite being the most populous county in the state, as of 1885, Pulaski County did not have its own courthouse. Instead, the county rented office space throughout the city for the use of county officials. To remedy this, the county hired architect Max Orlopp to design a courthouse. Work on the Romanesque building began in August 1887 and was completed in 1889. A tower designed by George Mann was added in 1913.

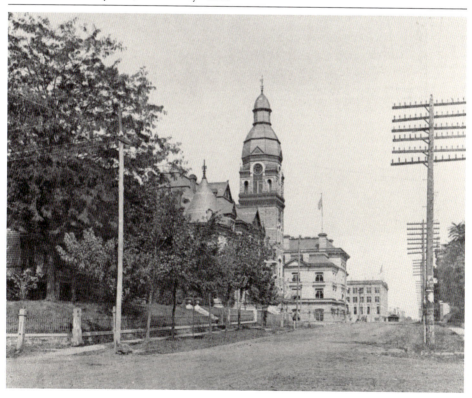

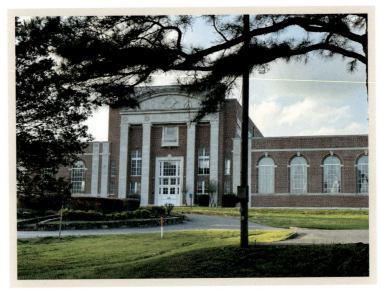

ARKANSAS DEAF MUTE INSTITUTE. Joseph Mount came to Little Rock in 1868. A hearing-impaired man, he saw the need for education for deaf people in Arkansas. He began a school in the city, operating out of a series of private residences. The school moved to its current location on Markham Street in 1868. The building in this photograph was completed in 1899. The current buildings housing the school were built in the 1960s.

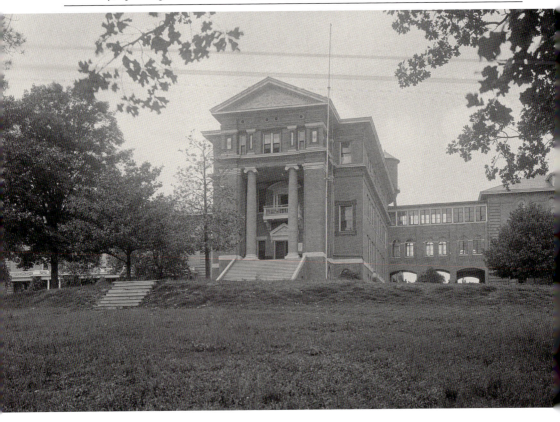

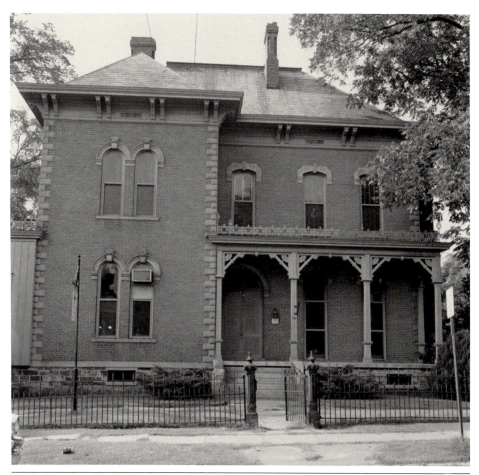

W.B. Worthen House. In Gilded Age Little Rock, one of the ways to rise to prominence was through banking. William Booker Worthen was born in Little Rock in 1852 and formed a banking and real estate firm with Gordon Neill Peay in 1876. In 1888, Worthen became the sole owner of the firm, leading one of the most profitable banks in Arkansas. He built this house in 1882 for his growing family. The house has since been demolished.

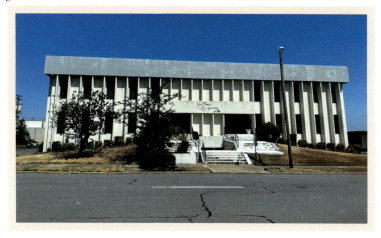

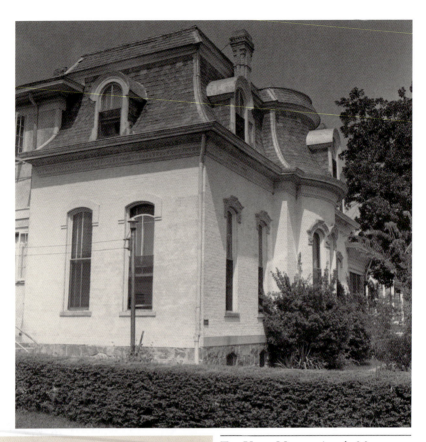

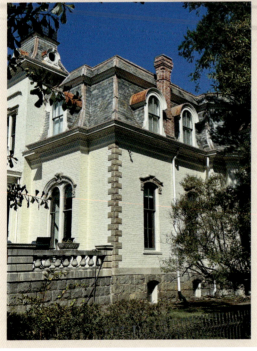

THE VILLA MARRE. Angelo Marre was born in Genoa, Italy, in 1842 and came to America in 1855. He settled in Little Rock in 1872 and established a successful saloon in the city. He built this home on Scott Street in 1881. The Italianate-designed house was almost demolished in the 1960s, but was saved. It became nationally known after the façade appeared in the opening credits of the sitcom *Designing Women* in the 1980s.

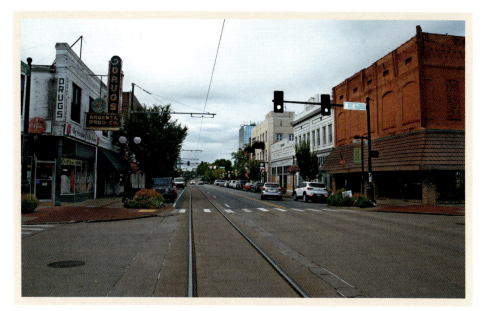

PAVING MAIN STREET, ARGENTA. Throughout the 19th century, Pulaski County's dirt roads were prone to become quagmires of mud. In 1910, James Mahoney formed the Argenta Paving Company and won the bid to pave Argenta's Main Street. By the end of the year, most of Main Street was paved, allowing for easier access to the city's growing business district. Main Street continues to thrive today as an entertainment district.

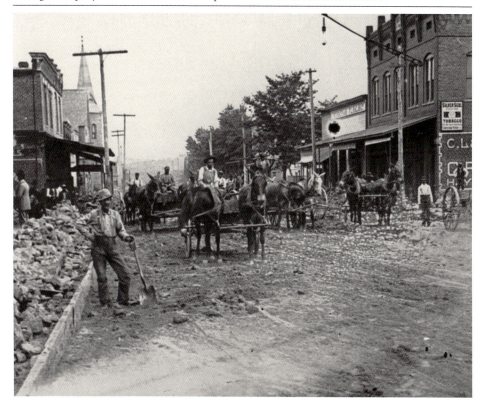

Pulaski County at the Turn of the Century

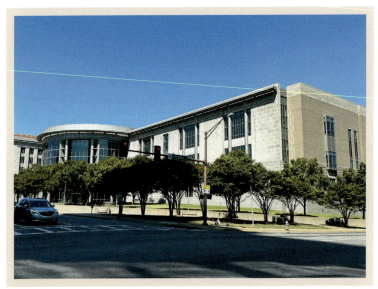

TEMPLE B'NAI ISRAEL. In 1866, Little Rock's Jewish community established the Temple B'nai Israel congregation. It erected its first temple in 1872. In 1897, the congregation built this Romanesque temple on the corner of Broadway and Fifth Streets in 1897. One of the more prominent leaders of the community was Rabbi Louis Witt, who served from 1907 to 1919. A new temple was built in West Little Rock in 1975, and this building was sold and demolished.

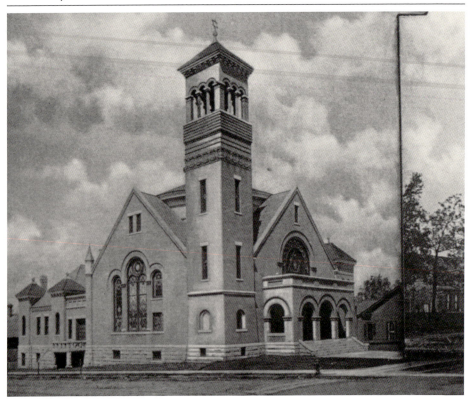

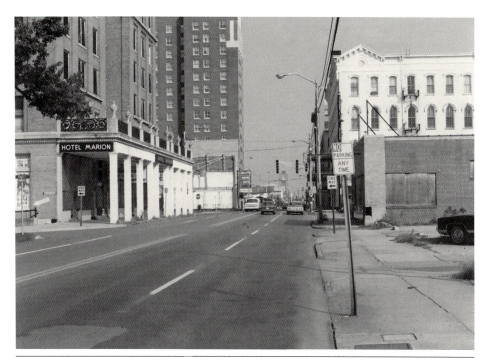

THE HOTEL MARION. German immigrant Herman Kahn became a prominent banker and businessman in the late 19th century. In 1905, he started the Hotel Marion Corporation to build a lavish hotel in the heart of Little Rock. The $250,000 Hotel Marion was the most extravagant hotel yet seen in the city, boasting 500 rooms. Demolished in 1980, the Marriott Hotel now occupies the space.

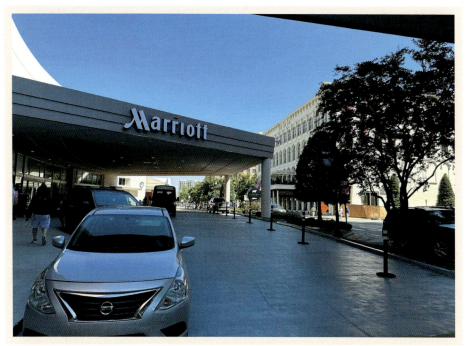

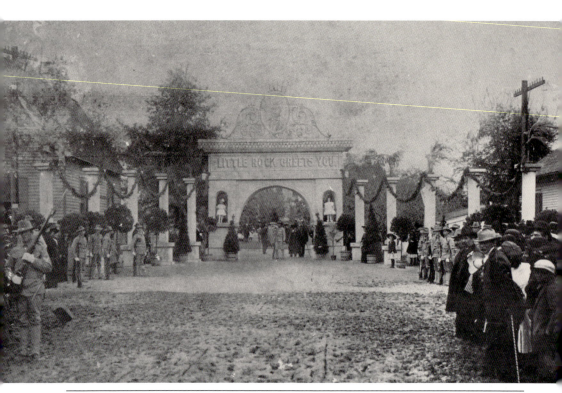

Delegation to Greet President Roosevelt. In October 1905, Pres. Theodore Roosevelt announced that he would visit Little Rock. With a month to prepare, city officials got to work arranging details for the visit. Every business along Little Rock's Main Street signed petitions pledging to decorate their premises with patriotic décor. The president arrived in City Park, now called MacArthur Park, to a large delegation of citizens cheering him.

LITTLE ROCK DURING ROOSEVELT'S VISIT. Roosevelt's 1905 visit drew the largest crowd that Little Rock had ever experienced. The Iron Mountain Railroad alone brought 28,769 visitors to the city to see the president. People crowded 10 blocks of the city, and many climbed to the tops of buildings or hung outside shop windows to get a glimpse of him.

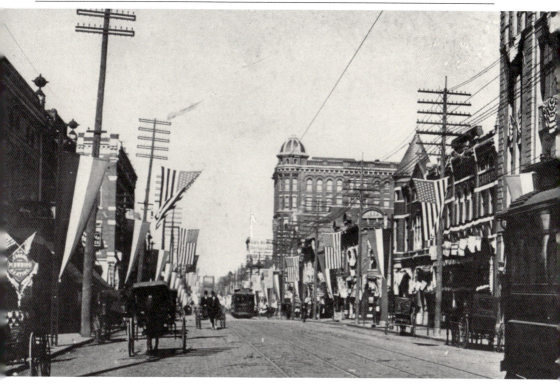

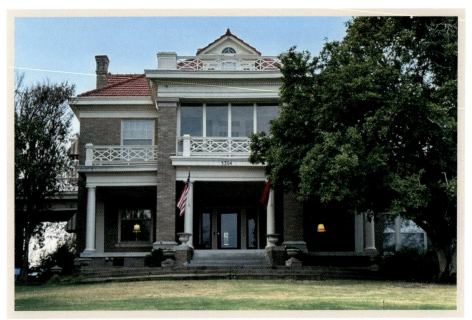

McDonnell-Hamilton House. In the first decade of the 20th century, Little Rock spread, creating new neighborhoods such as Pulaski Heights, Hillcrest, and Midland Hills. This allowed planners to devise creative ways to lay out the new neighborhoods. Instead of the grid style of most neighborhoods, Midland Hills streets were designed around the contours of the hilly terrain. This was attractive to Little Rock's business tycoons such as James Smith McDonnell, a cotton merchant, who built his mansion on Hill Road.

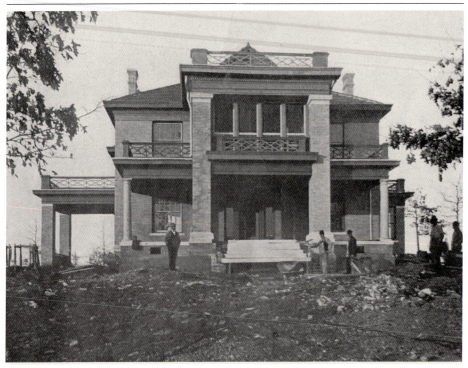

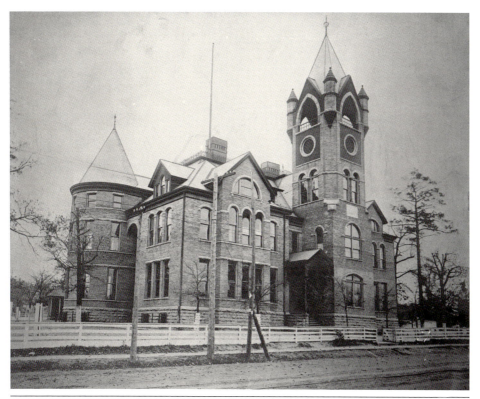

THE PEABODY SCHOOL. Little Rock's school-aged white children had several options for school. Most attended the Peabody School, a large church-like building funded by philanthropist George Peabody. The school's façade led many to believe that it was once a church, buoyed by the tombstones in its yard. Eventually, the tombstones were relocated to Mount Holly Cemetery. After the city high school was built, the Peabody School, now unoccupied, fell into disrepair. The building was demolished in the 1960s.

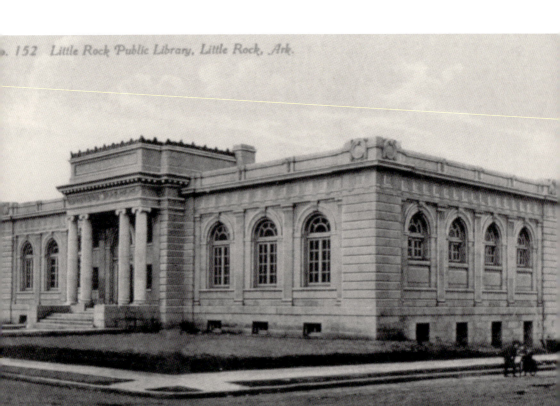

LITTLE ROCK PUBLIC LIBRARY. In 1906, the city applied for a grant from Andrew Carnegie of over $80,000 to build a public library. This structure was built on the corner of Seventh and Louisiana Streets and opened in 1910. By 1918, it possessed 27,000 volumes and served 16,000 borrowers. The building was demolished in 1964 after the library moved to Second Street. The columns that adorned the demolished building now grace the parking lot at the current library location.

CHAPTER 4

Pulaski County Enters the Progressive Era

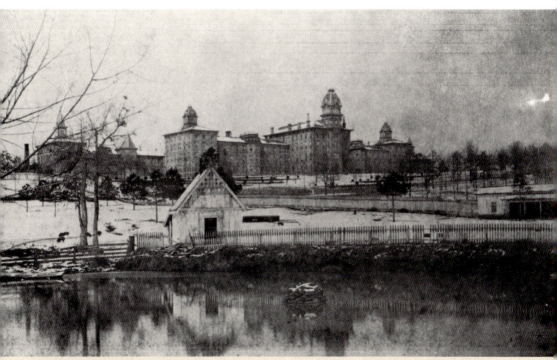

OLD STATE HOSPITAL. As Pulaski County entered the new century, it experienced some dramatic changes. Symbolizing this break from the past, the state built a new capitol building. State officeholders began to look to reform some of the state's institutions. They developed new tax systems to fund public schools and made other reforms to bring the county into the modern age. One change was the development of a state hospital to treat mental illness.

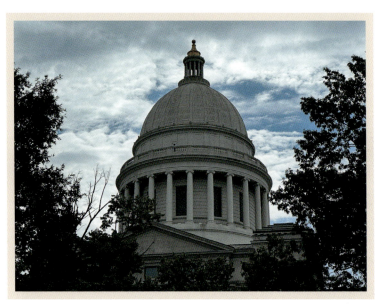

DOME OF CAPITOL UNDER CONSTRUCTION. A commission headed by Gov. Dan Jones selected the grounds of the former state penitentiary for architect George R. Mann to build a new capitol building in 1899. Gov. Jeff Davis was a main opponent of building the new capitol. His interference in the project led to long delays. In 1908, Governor Donaghey fired Mann from the job and hired Cass Gilbert to complete the building.

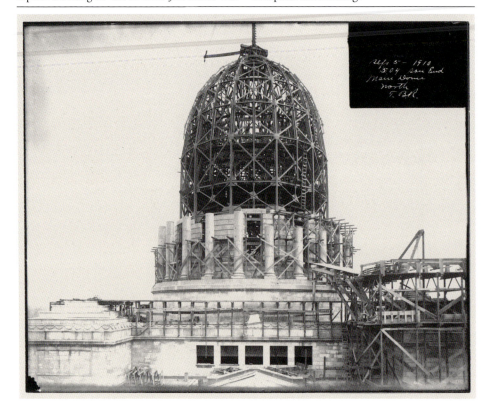

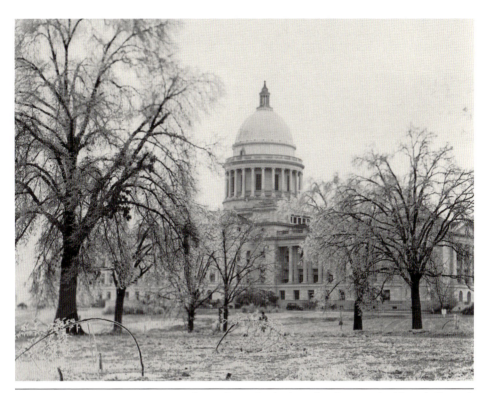

STATE CAPITOL COMPLETED. When the Arkansas legislature approved the new building, it was with the promise that it would cost no more than $1 million. However, due to the political wrangling that surrounded the project and the numerous delays that resulted, the budget for the new building ballooned. By the time the project finished in 1915, the new building cost twice the original estimate. Nevertheless, Arkansas had a new capitol building.

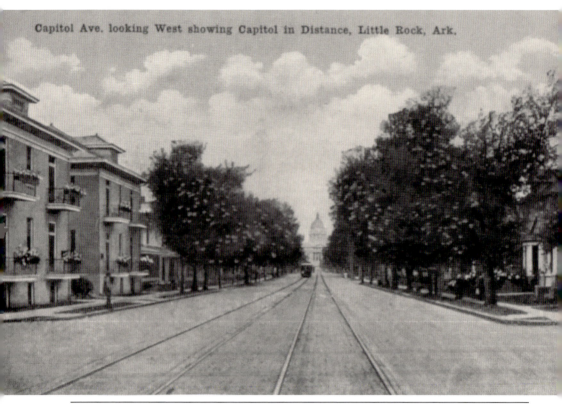

FIFTH STREET RENAMED CAPITOL AVENUE. The new capitol building brought development along Fifth Street in the heart of the city. Once residential, the neighborhood began to attract more businesses along the busy road. Retail outlets and government buildings began to relocate here to take advantage of the steady traffic going to the capitol. Little Rock officials approved renaming Fifth Street Capitol Avenue to reflect its new purpose as a thoroughfare from downtown Little Rock to the capitol.

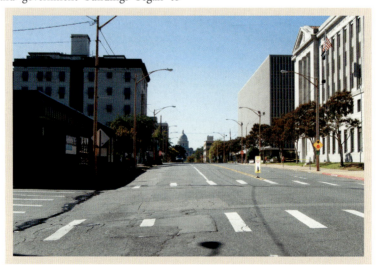

STATE HOSPITAL FOR NERVOUS DISEASES. Reform movements swept across the country after the Civil War, leading to the establishment of hospitals devoted to the care of the mentally ill. In 1873, the state legislature established the State Lunatic Asylum, renamed the State Hospital for Nervous Diseases in 1915. The current state hospital occupies the original site on Markham Street.

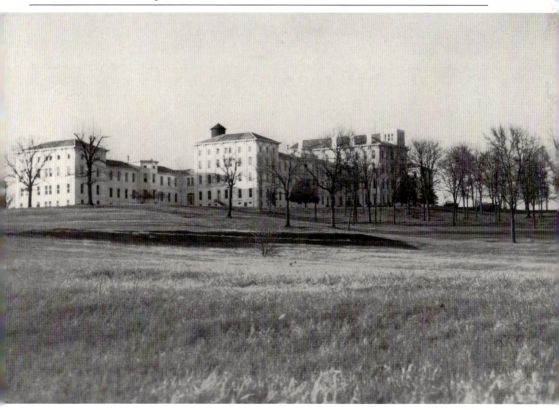

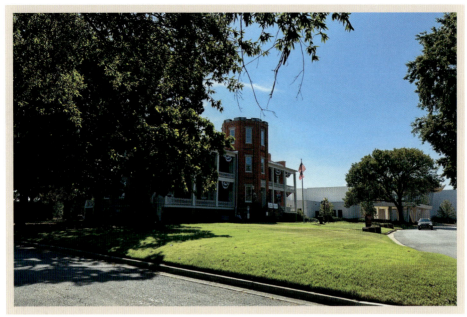

CITY PARK ON NINTH STREET. By 1893, the grounds of the Little Rock Arsenal were no longer being used for military purposes. Little Rock officials began to eye the land as a site for a park. They worked out a deal with the military to exchange the arsenal grounds for 1,000 acres north of the river. This became the site of Fort Roots, and the city developed the arsenal grounds into City Park.

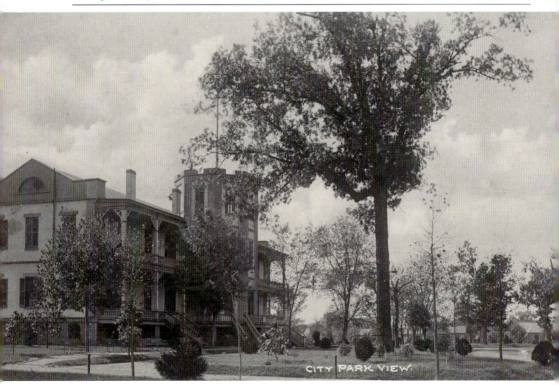

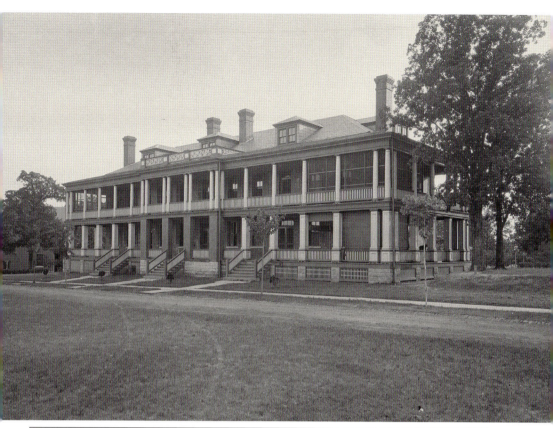

FORT ROOTS BACHELOR OFFICER QUARTERS. With a deal to exchange land in place, the US government announced the creation of a new military fort named in honor of the recently deceased businessman and politician Logan F. Roots. The fort held several barracks and administrative buildings, including this building, finished in 1906, that housed unmarried officers. The building has changed dramatically over the years, with the removal of the porch and other design changes.

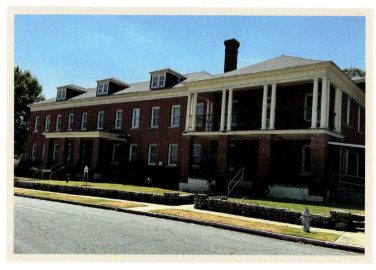

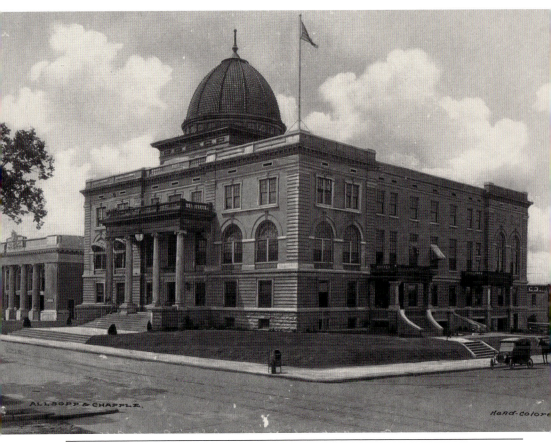

LITTLE ROCK CITY HALL. The original city hall building, erected in 1867, had fallen into disrepair within 20 years of its completion. In the late 1880s, city officials began considering replacing the building. It took years to convince the public of the need for a new city hall. The new building was completed in 1907 with a domed roof. By the 1950s, the dome had deteriorated and was removed as a safety precaution.

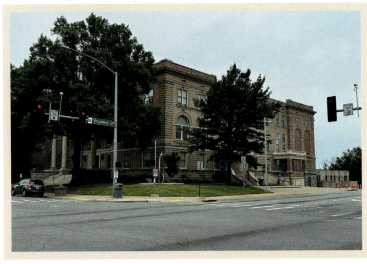

LITTLE ROCK FIRE STATION. In January 1911, a fire broke out in the Hollenberg Music store. Little Rock's firefighting equipment was no match for the fire, which soon destroyed the entire 600 block of Main Street. Following such disasters, Little Rock officials began planning to upgrade the fire patrol, including erecting this building on Markham Street next to the new city hall in 1913. The building is now home to city administrative offices.

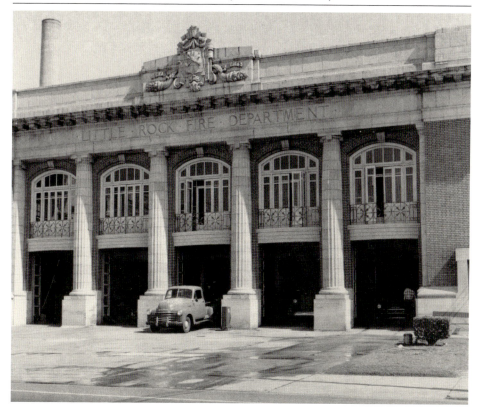

Pulaski County Enters the Progressive Era

The Boyle Building. The Boyle Building was erected in 1909 and housed bank offices and other retail outlets. In 1918, it was the site of a spectacle when "the Human Spider" Bill Strother climbed the building's 11-story façade and read a copy of the *Arkansas Gazette* while sitting on top of a flagpole. His stunt raised over $300 for the Salvation Army. The building still stands on the corner of Main Street and Capitol Avenue.

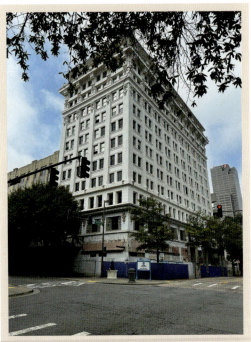

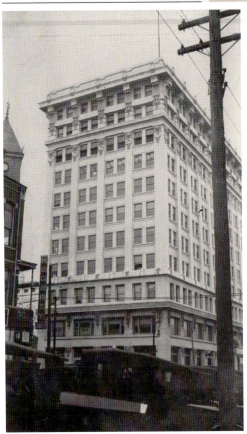

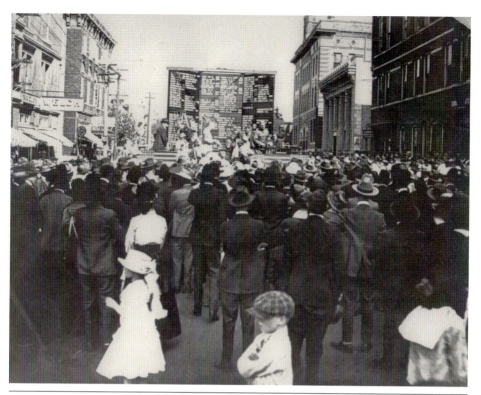

SELLING WAR BONDS. When the United States entered World War I in 1917, there was a rush of patriotism, and Arkansas citizens pledged their support of the war. The US government raised money for the war by issuing Liberty Bonds. Bond holders received flags to display in their windows as proof of their support. Mass Liberty Bond rallies were common, such as this one held on Little Rock's Main Street.

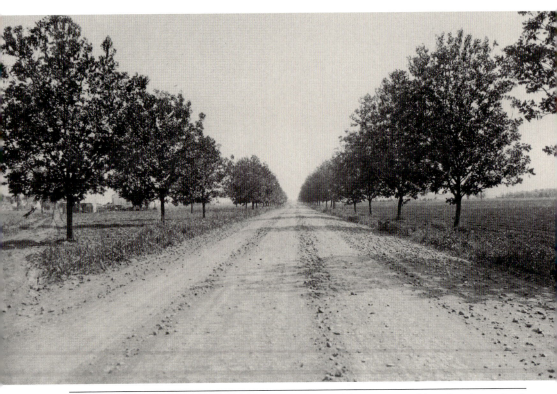

TREES NEAR SCOTT, ARKANSAS. James Robert Alexander was a North Carolina native who came to Arkansas around the turn of the 20th century. He became an overseer of the property owned by his cousin near Scott. Over the years, he saved his money and bought a large chunk of the land, which he named Land's End. Alexander built a mansion in the early 20th century and planted a line of pecan trees along the highway near his home.

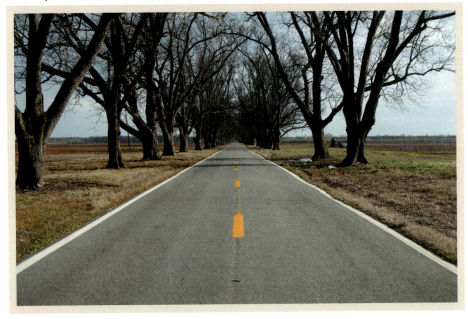

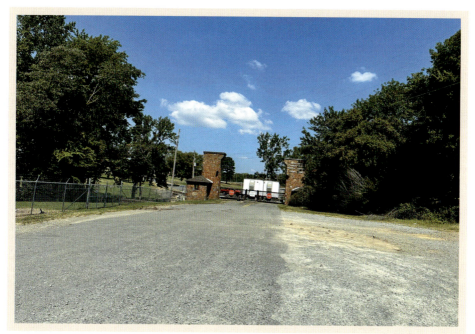

GATE AT CAMP PIKE. At the outbreak of World War I, community leaders hoped to attract a military training facility to Arkansas. They raised money from citizens to purchase a tract of land near Levy that was near railroad facilities. In 1917, the US government agreed to establish a training center there. They named the facility Camp Pike after explorer Zebulon Pike. Today, the gated entrance is all that is left of the World War I facilities.

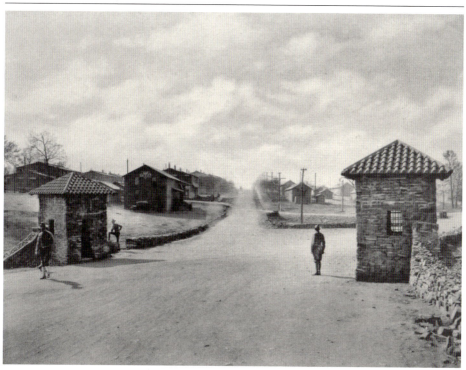

Pulaski County Enters the Progressive Era

ALLSOPP AND CHAPPLE. In 1884, at 17 years of age, Frederick W. Allsopp got a job as an office boy at the *Arkansas Gazette*. He became a business manager in 1902. Allsopp ventured into other businesses, opening the Allsopp and Chapple bookstore on Main Street. Although the bookstore closed years ago, a restaurant in the building has adopted the name Allsopp and Chapple as a nod to it.

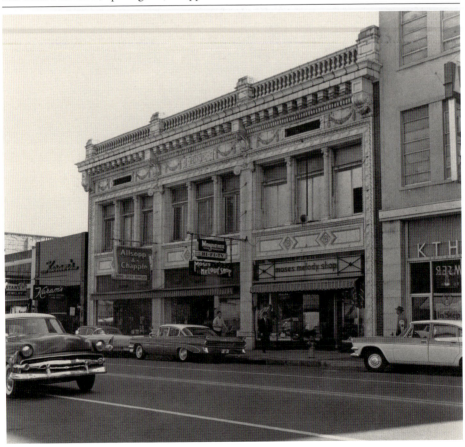

Pulaski County Enters the Progressive Era

BRIDGE, NORTHERN PULASKI COUNTY. Unlike the central region of the county, northern Pulaski County remained largely rural, home to small farms and cattle raising. The largest settlement was Bayou Meto. With the establishment of the Little Rock Air Base in 1953, the area became a mix of farm and military families. This also meant the upgrade of much of the rural infrastructure, as concrete bridges began to replace those made of wood.

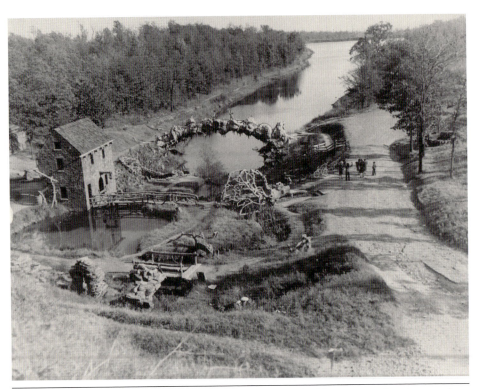

OLD MILL, LAKEWOOD. In the 1920s, Justin Matthews, a land developer, began work in Lakewood. He sought to give his new development a rustic feel. In 1932, he recruited architect Frank Carmean to design a building resembling a 19th-century water-powered mill. The "old" building was authentic enough to be featured in the opening credits of the 1939 film *Gone with the Wind*. The site has changed little and remains a park serving the local community.

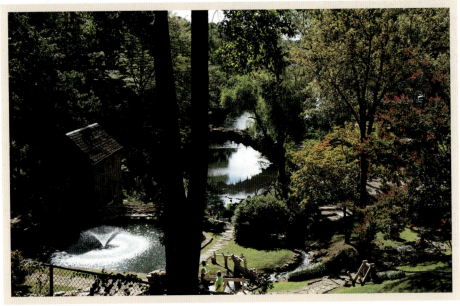

MASONIC TEMPLE UNDER CONSTRUCTION. Albert Pike had been a civic, political, and military leader in Arkansas since the 1830s. In 1850, he became a Mason, rising to be a national leader in Freemasonry. In 1901, Little Rock's Masons built the Albert Pike Consistory on Scott Street. After a fire in 1919 destroyed most of the former structure, the Masons started to rebuild on the same site. The building was completed in 1925 and is still standing.

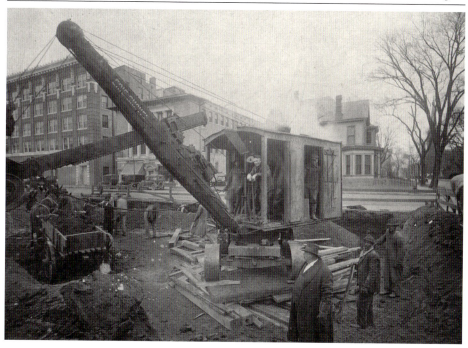

Pulaski County Enters the Progressive Era

ARGENTA HIGH SCHOOL. As Argenta continued to grow, it became clear to government officials that North Side School would not be able to accommodate the growing student body. As a result, in 1912, the city established Argenta High School on Fourth Street. The high school moved to the current site of North Little Rock High School in 1928, and Argenta High now housed the junior high. The building was abandoned and demolished in 1976.

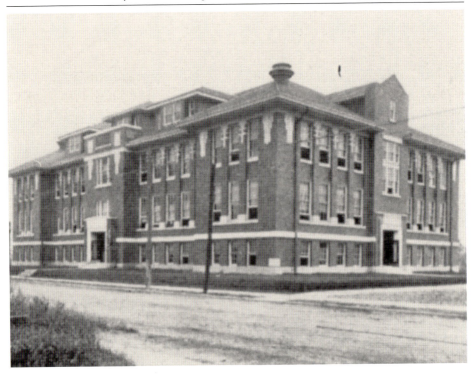

CHAPTER 5

Pulaski County in the Modern Age

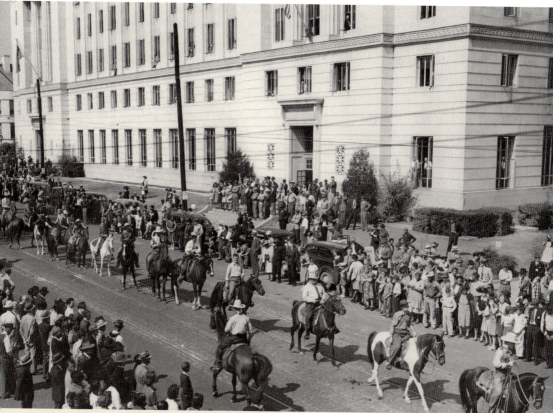

Parade near Federal Building. By the middle of the 20th century, Little Rock's streets were crowded. Outside the city, changes were afoot in Jacksonville, where the population exploded with the creation of Little Rock Air Base. Sherwood went from a sleepy hamlet to a populous suburb. In 1962, the federal government built the Federal Building on Capitol Avenue.

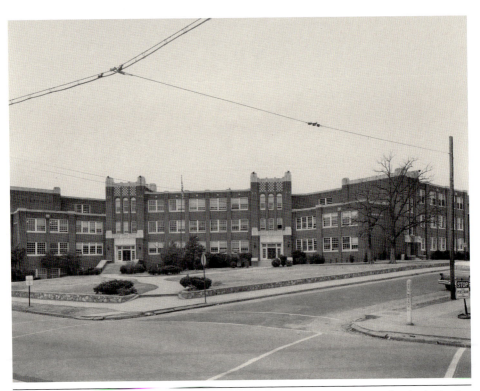

DUNBAR HIGH SCHOOL. In 1929, while white students enjoyed the new facilities at Central High School, African American students had to cope with underfunded segregated schools. Black leaders appealed to the Julius Rosenwald Foundation to fund a new building. With a grant from the organization, they built Dunbar High School, named after African American poet Paul Lawrence Dunbar. The school opened in 1930 and continues to operate as a magnet school.

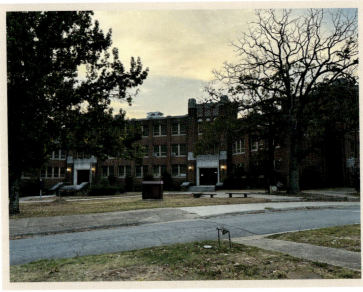

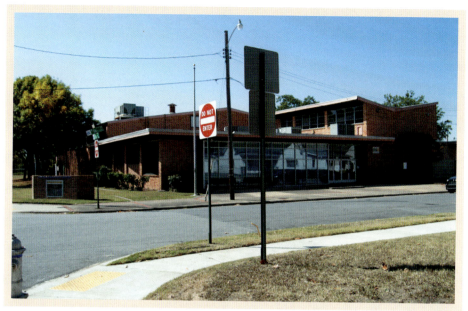

DUNBAR COMMUNITY CENTER. Dunbar High School became an important part of life for the African American community that coalesced around the school. The Dunbar neighborhood has been the home of several prominent African Americans, including attorney Scipio A. Jones and physician Dr. A.A. Womack. The Dunbar Community Center became a place for community engagement, arts, and enrichment. In the neighborhood are two historically Black colleges: Arkansas Baptist College and Philander Smith University.

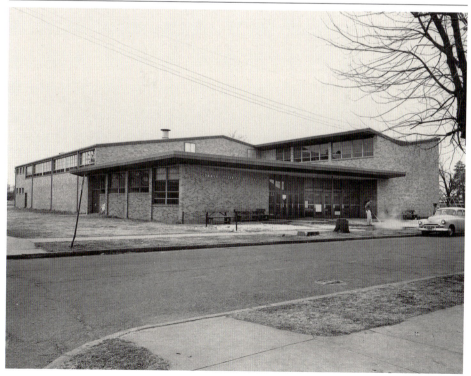

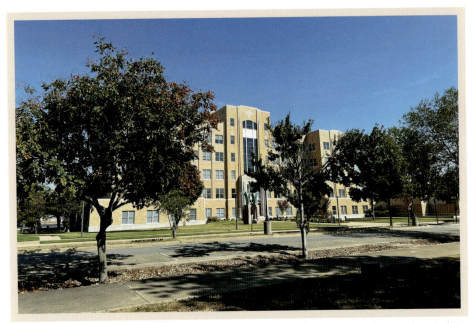

UNIVERSITY OF ARKANSAS LITTLE ROCK SCHOOL OF MEDICINE. The first medical school in Little Rock was established on Second Street in 1879. The first class was small, with only nine students. In 1935, the school erected a new building next to the city hospital. In 1950, the school moved to its current location on Markham Street. The old building now serves as the University of Arkansas Little Rock Bowen School of Law.

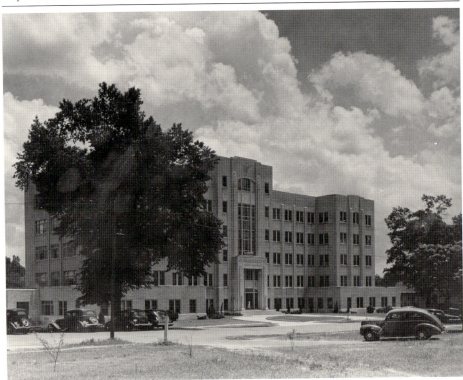

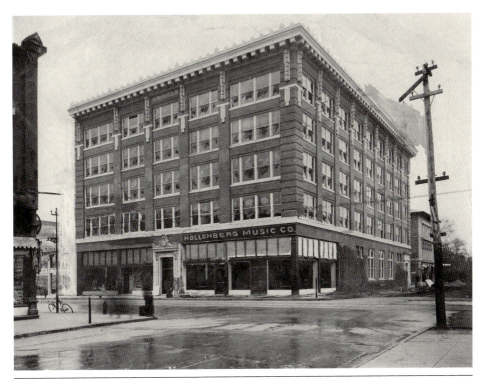

THE DONAGHEY BUILDING. Following his time as governor, George Donaghey remained active in community affairs. His skills in construction led to many building projects in the state, including this building on Seventh and Main Streets, erected in 1926. The structure was designed by architect Hunter McDonnell and was the tallest building in the state until 1930. In 1930, Donaghey donated the building to Little Rock Junior College, which later evolved into the University of Arkansas at Little Rock.

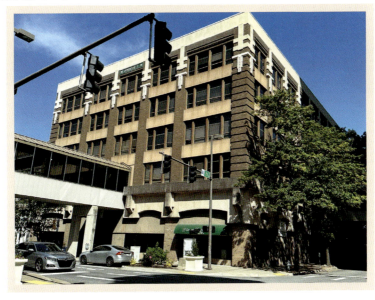

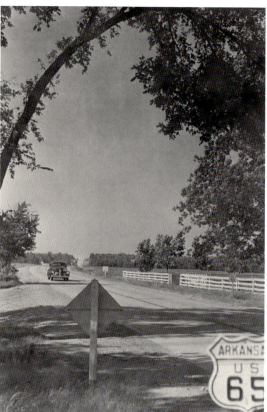

HIGHWAY 65, NEAR MAUMELLE. Automobiles transformed central Arkansas. Old gravel highways soon were paved, making travel easier. Now designated Highway 365, Highway 65 meandered from Pine Bluff to Conway, passing through central Arkansas. The road passes into Pulaski County at Hensley and exits the county north of Maumelle. Until the emergence of the federal interstate system, this was the main route between Maumelle and Conway.

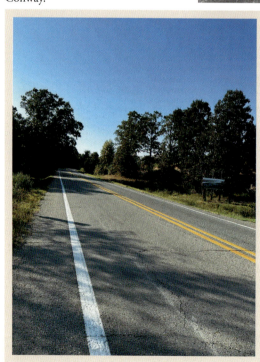

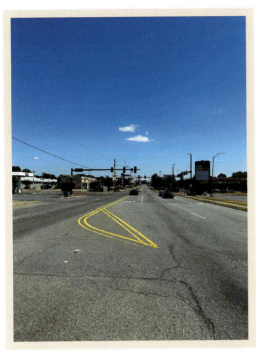

MAIN STREET, JACKSONVILLE. Jacksonville in 1941 was a sleepy hamlet with a population of around 100. The village was founded in 1870 when the Cairo & Fulton Railroad built a depot in the area and Jacksonville grew around it. It remained rural until the US military established an ordnance facility there in 1941 to equip the military during World War II.

Pulaski County in the Modern Age

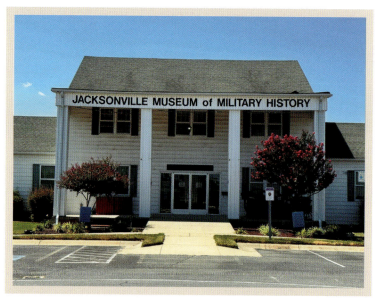

Ordnance Plant Hospital, Jacksonville. The ordnance plant employed hundreds of workers who flocked to Jacksonville for jobs. Among these were scores of women who were anxious to become "Rosy the Riveter" to aid the war effort. The plant became a self-contained town complete with a hospital behind this building. Currently, the plant grounds are the location for the Jacksonville Military Museum.

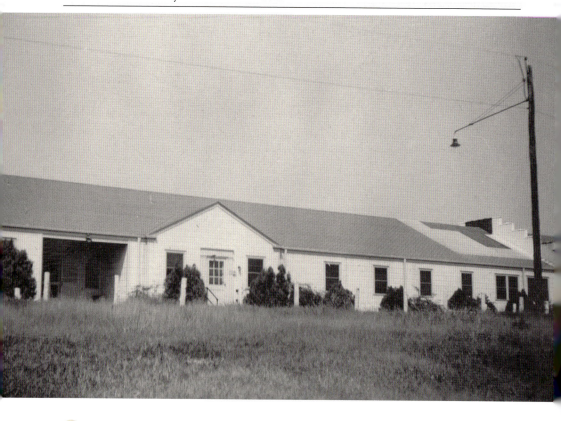

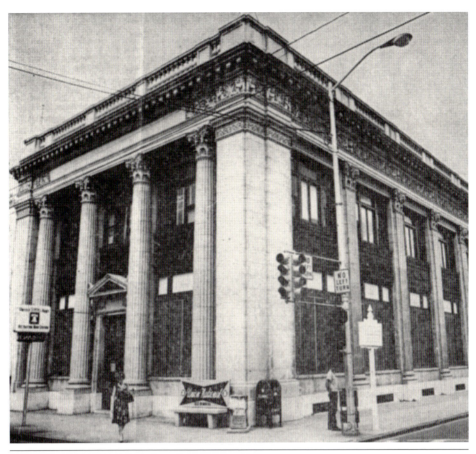

THE USO BUILDING. As the war effort was underway in Jacksonville, the Army established a training facility at Camp Robinson. An estimated 750,000 soldiers trained there while the war raged around the world. One of the entertainment outlets for soldiers was in downtown Little Rock, the United Service Organization, housed in the Bank of Commerce building on Third and Main Streets. It was demolished in the 1960s.

Pulaski County in the Modern Age

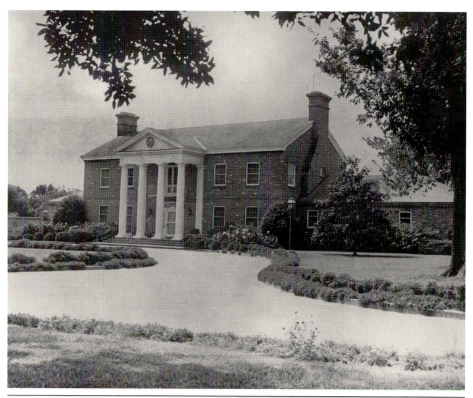

ARKANSAS GOVERNOR'S MANSION. Arkansas governors lived in private residences until the 1950s, when the legislature appropriated money to build an official residence for the state's top executive. The building was finished in 1950. Its first resident was Gov. Sydney McMath and his family. The mansion was largely unchanged until the 1990s, when Gov. Mike Huckabee added a reception hall to the rear of the structure.

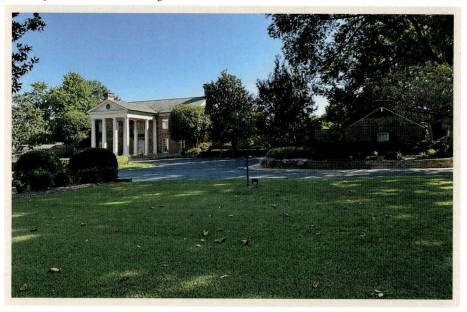

NINTH STREET, LITTLE ROCK. After the Civil War, many freed slaves built cabins on what was then called Hazel Street just north of Mount Holly Cemetery. Over the years, the area developed into a largely African American community. Since Little Rock remained segregated, African Americans created their own business district on Hazel Street, which was later renamed West Ninth Street. African American–owned businesses thrived in the district.

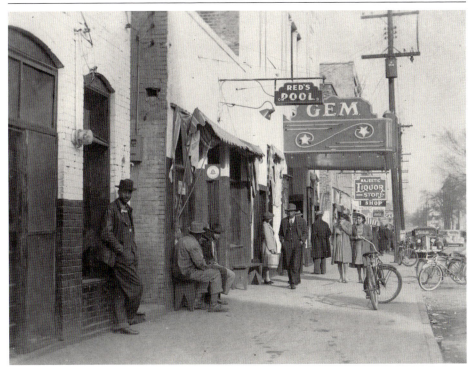

Pulaski County in the Modern Age

87

Ninth Street, Little Rock. In addition to businesses, the area became known as an entertainment center. In the background of this photograph is Taborian Hall, built in 1918 and home to the Knights and Daughters of Tabor, an African American fraternal organization. On the top floor of the building was the Dreamland Ballroom, a dance hall that featured many nationally known African American musicians. While most of the Ninth Street business district has disappeared, Taborian Hall remains.

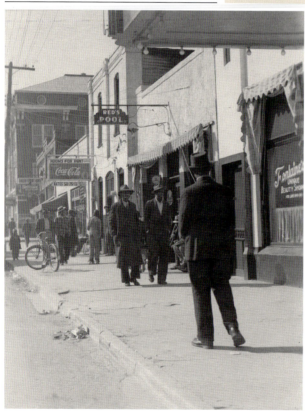

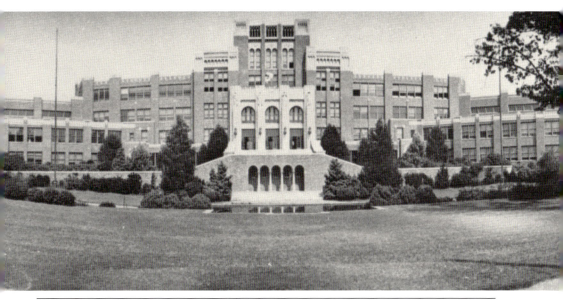

LITTLE ROCK CENTRAL HIGH SCHOOL. In 1954, the US Supreme Court issued the *Brown v. Board of Education* decision outlawing segregation and ordered segregated schools to integrate. In Little Rock, nine African American students made national news as they attempted to desegregate the previously whites-only Central High School. The building, erected in 1927, became a symbol of the civil rights movement. Daisy Gatson Bates, a civil rights leader, helped organize the efforts to integrate the school.

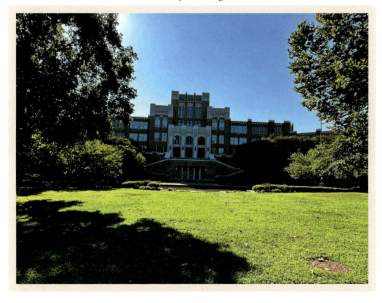

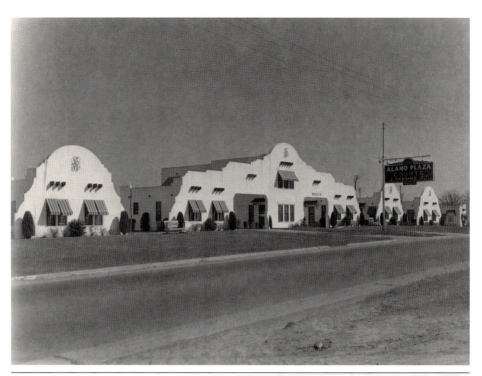

ALAMO PLAZA TRAVEL CENTER. The invention of the automobile made Americans more mobile. After the 1930s, travel centers began to appear around central Arkansas to cater to families embarking on the "Great American Road Trip." Travel centers became ubiquitous in Pulaski County. These travel centers were self-contained villages with individual bungalows and restaurants. Families visiting Little Rock could stay at this travel center on Roosevelt Road.

119 South Main Street. In the 1960s, retail outlets began disappearing from downtown Little Rock in favor of suburban areas. Going to shopping malls in the suburbs replaced trips to the city. The inner city began to fall into disrepair as buildings stood vacant. Taking advantage of federal programs that paid for demolishing abandoned houses and office buildings, Little Rock began destroying historic buildings throughout the city, such as this entire block on Main Street.

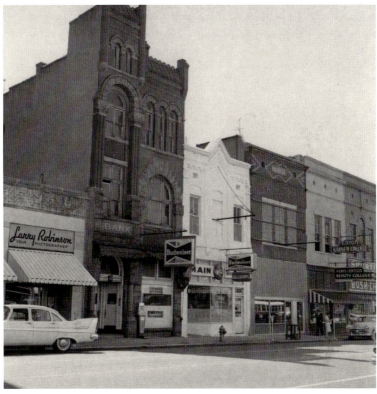

Pulaski County in the Modern Age

119 South Louisiana Street. As a result of this "revitalization," blocks that once housed important businesses, such as this one on South Louisiana Street, were demolished and turned into parking lots. Many of the historic buildings in this book suffered the same fate, as history was sacrificed for "progress." In the past two decades, many businesses have begun to return to downtown and now occupy the few remaining historic buildings in the city.

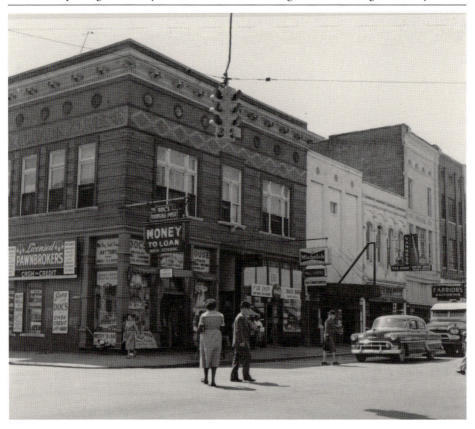

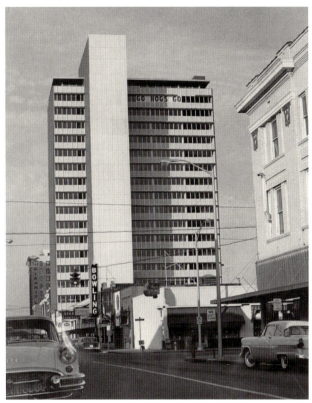

THE TOWER BUILDING. Before he became governor in 1967, Winthrop Rockefeller had been a tireless advocate for modernizing Arkansas. He encouraged the establishment of a multi-story high-rise office building in Little Rock. To plan the construction, Rockefeller brought together a team of architects and engineers. Construction began on Fourth and Center Streets in 1959 and finished in 1960. At the time of its completion, it was the tallest building in Arkansas. It remains an active office complex.

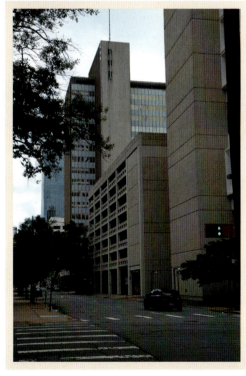

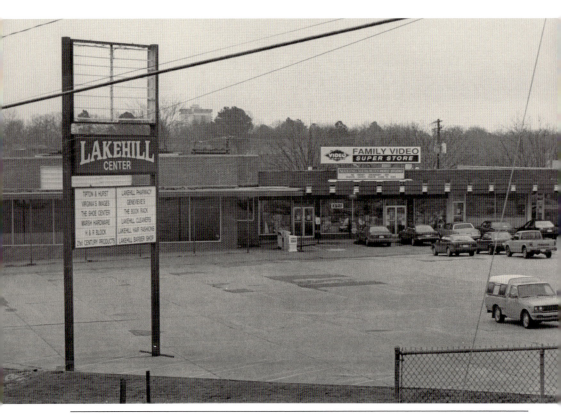

LAKE HILL CENTER, PARK HILL. The trend of moving to the suburbs affected Pulaski County. Downtown Little Rock suffered, but the movement was a boon to suburban communities like Park Hill. Although it had a pre-existing community dating to the 1920s, Park Hill grew dramatically in the 1960s through the 1980s. Outlet malls appeared in the community, such as Lakehill Center on JFK Avenue.

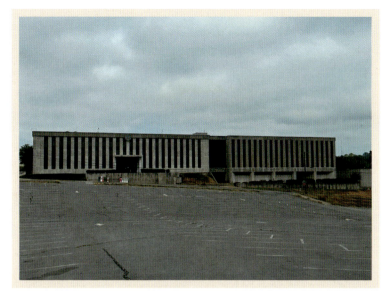

ARKANSAS DEPARTMENT OF COMMERCE BUILDING. In the latter half of the 20th century, Arkansas state government grew more complex. Reflecting this growth, the Capitol Complex also grew. Government departments built several state office buildings west of the capitol. One of these is the Department of Commerce Building on Wolf Street. The growth of the Capitol Complex was symbolic of the growth of the county. Pulaski County had become a modern county ready for the 21st century.

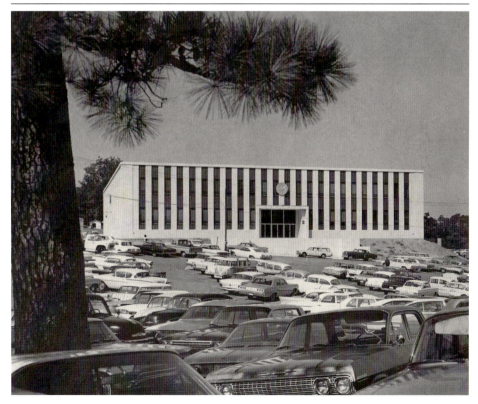

Pulaski County in the Modern Age

Discover Thousands of Local History Books Featuring Millions of Vintage Images

Arcadia Publishing, the leading local history publisher in the United States, is committed to making history accessible and meaningful through publishing books that celebrate and preserve the heritage of America's people and places.

Find more books like this at
www.arcadiapublishing.com

Search for your hometown history, your old stomping grounds, and even your favorite sports team.

Consistent with our mission to preserve history on a local level, this book was printed in South Carolina on American-made paper and manufactured entirely in the United States. Products carrying the accredited Forest Stewardship Council (FSC) label are printed on 100 percent FSC-certified paper.